HAWORTH, OXENHOPE & STANBURY From Old Maps

In memory of my friend Jack Cuthbert, who loved Haworth.

HAWORTH, OXENHOPE & STANBURY From Old Maps

Steven Wood

AMBERLEY

First published 2014

Amberley Publishing
The Hill, Stroud
Gloucestershire, GL5 4EP

www.amberley-books.com

ISBN 978 1 4456 2148 7 (print)
ISBN 978 1 4456 2154 8 (ebook)

British Library Cataloguing in
Publication Data.
A catalogue record for this book is
available from the British Library.

Typeset in 11pt on 12pt Sabon LT Std.
Typesetting by Amberley Publishing.
Printed in the UK.

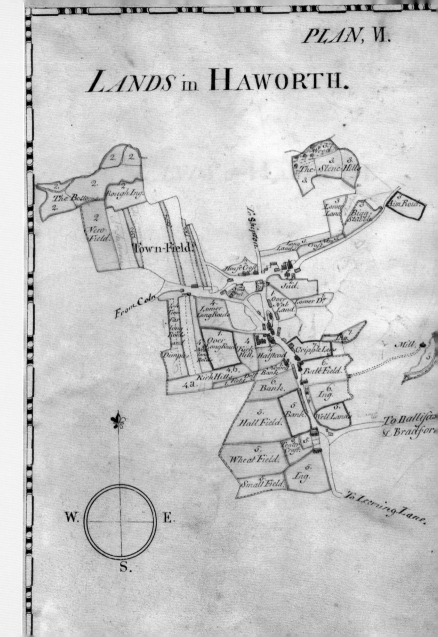

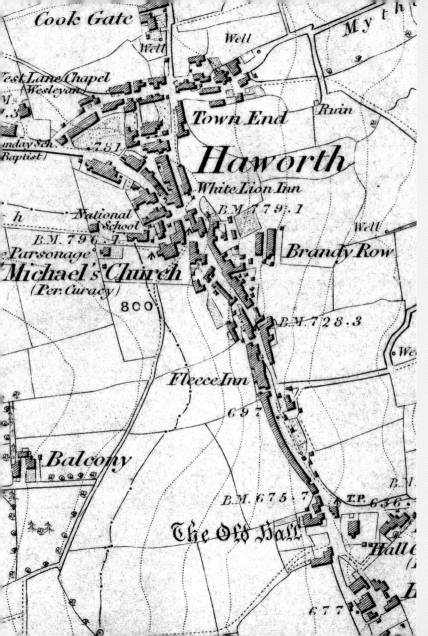

CONTENTS

ACKNOWLEDGEMENTS

Many of the maps in this book have come from library and archive collections. I am grateful to the keepers of the following collections for permission to make use of their maps: Keighley Local Studies Library, Bradford Central Library, the West Yorkshire Archive Service's offices at Bradford, Leeds and Wakefield, The Borthwick Institute of Historical Research in York, Cliffe Castle Museum at Keighley, and the Keighley & Worth Valley Railway. Thanks are also due to the staff of these repositories over the past quarter century and more for their knowledge, patience, help and, in many cases, friendship over the years.

I hope her colleagues will not mind if I make particular mention of Liz Osowska, whose loss is still deeply felt at Bradford Library almost twenty-five years after her untimely death.

The following maps are reproduced with permission from the collections of the West Yorkshire Archive Service:

57, 64, 80, 83a; WYAS Bradford 89D77/1, BDP48, 57D81 10/42, 57D81 10/7.
23, 59; WYAS Leeds WYL333/61, WYL647/1/659.
37, 87; WYAS Wakefield C193/1/192, QE20/2/16.

It is inevitable that a book of this kind is going to rely heavily on the maps and plans of the Ordnance Survey. They have been constantly used for reference throughout the preparation of the book. More visibly, there are nine extracts from OS maps of 1852, 1894 and 1934 reproduced in these pages. It is a pleasure to acknowledge my indebtedness to the incomparable works of our national map-makers.

For maps and pictures from private collections I am very happy to thank the following: Roger Caton, Rodney Heaton, Hazel Holmes, John A. Lees, John Rose, the Revd Jenny Savage and Keith Spencer. Ian Palmer has kindly given me permission to make use of his photograph of the model of Haworth old church and that of Haworth village which appears at the start of the book. My thanks to Kathryn Poulter for permission to quote from Lizzie Rignall's autobiography *All So Long Ago*. Thanks are also due to Paula Gerrard of the Special Collections Library at Brunel University, which holds the manuscript.

Numerous people have helped with many aspects of the book. As always, I am much indebted to my fellow Haworth (and Oxenhope!) historians Michael Baumber, Robin Greenwood, Reg Hindley and the late Dennis Thompson. For help with special topics I must thank Robin Greenwood (the Greenwood family), Reg Hindley (the Oxenhope enclosures), Eddie Kelly (public houses), John A. Lees (the Emmott estate maps), David Pearson (railways) and Arthur Walker (also railways).

The whole text has been read by Ann Dinsdale, Reg Hindley, David Smith (not to be confused with the author of the map books cited in the bibliography) and Lynn Wood, who have steered me clear of many pitfalls. Any remaining ones into which I may have fallen are entirely my responsibility.

INTRODUCTION

Old maps are fascinating and often beautiful documents. They are also one of the local historian's most important sources of information. In conjunction with old photographs and written sources, they can allow us to build up a very full picture of our town or village as it was 100 or more years ago. When I first moved to Haworth more than twenty-five years ago, one of the first things I did was to get photocopies of the old Ordnance Survey maps of the village from my local library. Those few sheets of A4 have now grown to a long bookshelf full of display files filled with photocopies of a great variety of maps of Haworth township and its surrounding district. In more recent years, I have built up a parallel collection of scanned maps on a succession of increasingly powerful computers.

Having recently published two volumes of old photographs of Haworth township (*Haworth, Oxenhope & Stanbury From Old Photographs*, Volumes 1 and 2, Amberley, 2011), I have now selected nearly 100 maps covering a period of over 300 years to complement those pictures. These give a great deal of information about the three villages of Haworth, Oxenhope and Stanbury and the farms and moors between and beyond them. The maps are divided into ten sections comprising different types of map: county and Ordnance Survey maps, Board of Health, tithe award, house repopulation plan, enclosure, estate maps and sale plans, church plans, plans of the waterworks, railway and road plans and building plans. The house repopulation plan is a particular feature of this book, which shows exactly who lived where in Haworth in 1851. Divided into twelve sections (maps 24 to 35), it gives some idea of the depth of detail that can come from combining maps with written records.

Each section starts with a brief introduction and notes on the individual maps. Cross references in the text give the map number – not the page number – in brackets. The maps follow, one to a page with a one-line caption giving the title and date. At the end of each caption (in brackets) is the approximate scale factor and, in most cases, the resultant scale of the map. To give an example, map 13 shows the whole of the 120 inch to 1 mile 1853 Board of Health plan of Haworth village spread across two pages. It is reduced to a fifth of the original scale (x0.2) giving a scale of about 25 inches to 1 mile. On the following pages (maps 14 to 17) the same map is shown in sections at half the original scale (x0.5) or 60 inches to 1 mile. These figures are to be regarded as rough guides only. A slight reduction has had to be applied to all the maps since the scale factors were calculated, but this will make little or no practical difference.

Most of the maps have been scanned directly from the originals for this book. In a few cases where the originals were not readily accessible the scans are from photocopies. Most of the scans have been cleaned up digitally. In some cases I have had to rearrange or delete some features (e.g. scale bars, north arrows, later annotations, enlarged details) of a map, but the map itself has not been altered other than by cropping and scaling. The sole exception is noted in the text (63). Some maps will need turning round clockwise to view properly – this will be obvious from text on the map. Map 61 conforms to this practice in order to match the orientation of 62, although this does put the text upside down. Readers may well find a magnifying glass useful from time to time.

As well as presenting a wide range of maps of the Haworth area and much information about them, this collection should also serve as an introduction to the use of maps in local history. Any reader who is inspired to start looking at maps of their own area will want to know where to start looking for them. More and more maps are becoming available online, but there is still a long way to go before these will supplant the original sources. The majority of my maps have come from the collections of local libraries

and record offices. Keighley Local Studies Library holds a good collection of printed maps of Keighley and the Worth Valley. It also, unusually, has a very large archive collection which, over the past twenty or thirty years, has yielded all manner of manuscript plans as well as all the building plans. Bradford Library also holds a fine map collection with a good number of maps of the Haworth area. Large regional libraries (Leeds, Manchester and the like) often hold countywide collections of Ordnance Survey maps, which can fill gaps in local holdings. The offices of the West Yorkshire Archive Service have produced maps of one sort or another for this book. The Leeds office is the main repository for the hugely important tithe maps and apportionments in the West Riding. Local museums are very likely to have collections of maps either as part of their main collections or as research tools for museum staff. You will need to make an appointment but should be able to see these on application. One of my maps in this book is in the collections of Cliffe Castle Museum and is made of wood. This is the model of Haworth old church (65), and what is a model but a three-dimensional map?

You will probably be surprised to find how many old maps people have in their houses – not just map collectors but people who have acquired maps along with property they have bought, through inheritance or just by chance. (It's amazing what comes out of skips!) Finding these takes time but as your interest becomes more widely known they will start to appear.

When you come to make copies of maps it is usually necessary to copy them in A4 sections (perhaps reduced to 71 per cent of the original size, A3 to A4 reduction). Get colour copies if you possibly can. Resist the temptation to stick your A4 sheets together to recreate the whole map. They will be much easier to handle if you to put the A4 sections in clear plastic pocket display files. If you get the chance to scan your maps, make colour scans at 600 dpi and save them as TIFFs. Again you will have to copy the map in sections, but these can be joined up in Photoshop. The possibilities of linking digital maps to other types of information (using hyperlinks in Acrobat documents for example) are beginning to be explored and will prove invaluable in future.

Finally, a couple of decades haunting second-hand bookshops, antique shops and book fairs will produce your own collection of original maps of your area. Look out for specialist dealers who issue regular catalogues of local history materials (Lesley Aitchison in Bristol is a good example).

To get the most out of maps it is useful to read some of the excellent books about them. A short list is given here:

Beech, G. & Mitchell, R., *Maps for Family and Local History* (2nd ed., 2004)
Hindle, P., *Maps for Local History* (1988)
Hollowell, S., *Enclosure Records for Historians* (2000)
Kain, R. J. P., and Prince, H. C., *Tithe Surveys for Historians* (2000)
Oliver, R., *Ordnance Survey Maps – a concise guide for historians* (2005)
Smith, D., *Antique Maps of the British Isles* (1982)
Smith, D., *Victorian Maps of the British Isles* (1985)
Smith, D., *Maps and Plans for the Local Historian and Collector* (1988)

Steven Wood,
Haworth

COUNTY & ORDNANCE SURVEY MAPS

County Maps

1. John Speed, York Shire, 1610

One year in the 1570s Haworth may well have been visited by Christopher Saxton, who was making an atlas of the counties of England. He is likely to have climbed the church tower with one or two knowledgeable Haworth men to point out and name the principal features of the district. Saxton's map of Yorkshire appeared in 1577 when it was sold for fourpence.

It now sells for thousands of pounds and is very scarce. No copy was available for use in this book, but fortunately there is a very fine map of 1610 by John Speed, which is based on Saxton's survey. This extract from Speed's map is centred on Haworth and shows the rivers, hills, towns, villages and parks of the district. Both branches of the River Worth are shown along with Oxenhope, Haworth itself, Laycock, Denholme deer park and Keighley (which appears as 'Highley').

2. Thomas Jefferys, The County of York, 1771

For two centuries after Saxton, cartographers were content to produce maps that were based on those of Saxton and Speed with little new information added. It was only in 1771 that a map of Yorkshire based on a completely new survey was published. Jefferys' map portrays Yorkshire at 1 inch to the mile on twenty sheets. It is the first map of the county at this scale and the first to show all the major roads. Haworth has roads going to Stanbury, Oakworth, Keighley (via Hainworth), Cullingworth and Oxenhope. Principal houses and their owners are shown (Heaton's Ponden House for example) and the corn mills at Ponden and Haworth.

3. Christopher Greenwood, Map of the County of York, 1818

The next new survey was that made by Christopher Greenwood using the triangulation of the Ordnance Survey as a basis. Although slightly smaller in scale than Jefferys' map, it shows a good deal more detail and is, no doubt, more accurate. For the first time minor roads are shown along with many more minor place names. Mills are shown, as they are on Jefferys' map, by a waterwheel symbol. These are now largely textile mills rather than corn mills. Sixteen mills are shown in Haworth township alone.

The Ordnance Survey

The Ordnance Survey published its great map of Yorkshire at the large scale of 6 inches to the mile on 311 sheets between 1847 and 1857. From then until the present time new editions of the 6 inch maps have appeared every twenty years or so, and since the 1890s plans at the 25 inch scale have been published for all but the most sparsely inhabited regions of the county. These maps and plans are among the most important of all sources for the local historian. Each of the three villages is represented here by extracts from the 6 inch map of 1852 and the 25 inch plans of 1894 and 1934.

4. OS 6 inch, Yorkshire sheet 200, 1852; Haworth
5. OS 6 inch, Yorkshire sheets 200 & 215, 1852; Oxenhope
6. OS 6 inch, Yorkshire sheet 200, 1852; Stanbury

The first edition 6 inch Ordnance Survey map is the most detailed map to cover the whole country in the mid-nineteenth century. We are fortunate that those for the Haworth area were among the earliest to be published, having been surveyed in 1847. The early date of the maps makes them invaluable for comparison with the 1850 Haworth tithe map.

They display not only the minor roads but also the streets of the villages, and are the first maps to show field boundaries for the whole township. Churches, chapels, schools, farms, mills and public houses are all named.

Boundaries of parishes, townships and hamlets are all shown in great detail along with those of counties and wapentakes. These are particularly obvious on the Stanbury map where the hamlet boundaries have been picked out in colour for local government use. Contour lines appear here for the first time, making it possible to visualise the landscape in three dimensions. Benchmarks and spot heights also give accurate height figures at regular intervals.

7. OS 25 inch, sheets 200.10/11, 1894; Haworth

8. OS 25 inch, sheets 200.14/15 & 215.2/3, 1894; Oxenhope

9. OS 25 inch, sheet 200.10, 1894; Stanbury

While the 6 inch survey of the northern counties was proceeding, the Ordnance Survey was embroiled in the 'Battle of the Scales'. The Treasury argued for a cheap survey at 1 inch to the mile, while many cartographers favoured the much larger 25 inch scale. Fortunately the professionals won the argument and in 1858 it was decided that cultivated districts should be surveyed at the scale of 1:2500. The mountainous and moorland parts of the country would continue to be surveyed at the 6 inch scale. It was not until the early 1890s that the 25 inch survey reached the Haworth district. Since then the majority of Haworth township has been surveyed at the larger scale, with just the most westerly parts of Haworth and Stanbury Moors being surveyed only at the 6 inch scale.

Comparison of these plans with the first edition 6 inch maps will show how much more detail was included. Notable on the Haworth plan is the appearance of what amounts to a new village at Haworth Brow where there had been only scattered farms. This new district, along with other new streets to the south of the old village, housed workers in the mills, which had grown much larger. This was at least partly a result of the opening of the Worth Valley branch railway, which is also shown here for the first time. It is notable how many of the occupants of the new houses came from three districts: Swaledale (where the lead mines were closing), Dauntsey in Wiltshire (which

was suffering from the widespread agricultural depression) and Foleshill in Warwickshire (a silk weaving district). The link between Haworth and Swaledale remained strong enough for the Brontë Bus Company to run an annual trip to Reeth show into the 1970s.

The Oxenhope plan shows an area rather further north than the extract for the 6 inch map. This is to take in the new development along Station Road (although the station itself is not shown).

The first of the two numbers that appear in each field is an OS reference number, which changes from edition to edition. The second is the area of the field in acres.

10. OS 25 inch, sheets 200.10/11, 1934; Haworth

11. OS 25 inch, sheets 200.14/15, 215.2/3, 1934; Oxenhope

12. OS 25 inch, sheet 200.10, 1934; Stanbury

A second edition of the 25 inch survey was published in 1909 and a third just after the First World War. Here we have extracts from the fourth edition of 1934.

It will be seen that Haworth village has not grown greatly since the 1894 survey. The main changes here are the Board Schools in Butt Lane, which opened in 1896, the Central Park of c. 1927 and the expansion of Bankfield Quarry to the west of Main Street.

Oxenhope is still the rather loose arrangement of streets and mills, with a good deal of open space within the village, which had developed by 1894. It was not until the late twentieth century that these gaps were filled with new housing.

Stanbury village alone has escaped extensive development. The 1934 plan shows very little change compared with the 1852 6 inch map. Indeed, Stanbury is still much the same today.

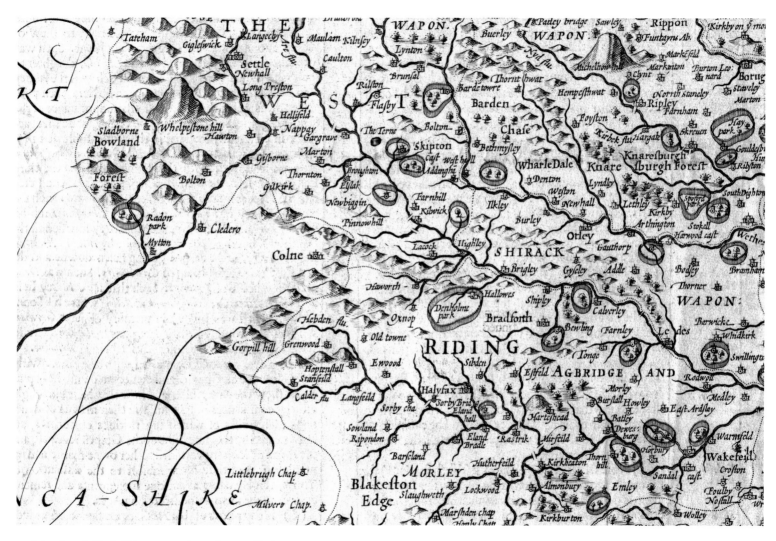

1. John Speed, York Shire, 1610. (XI; 1" = 5 miles)

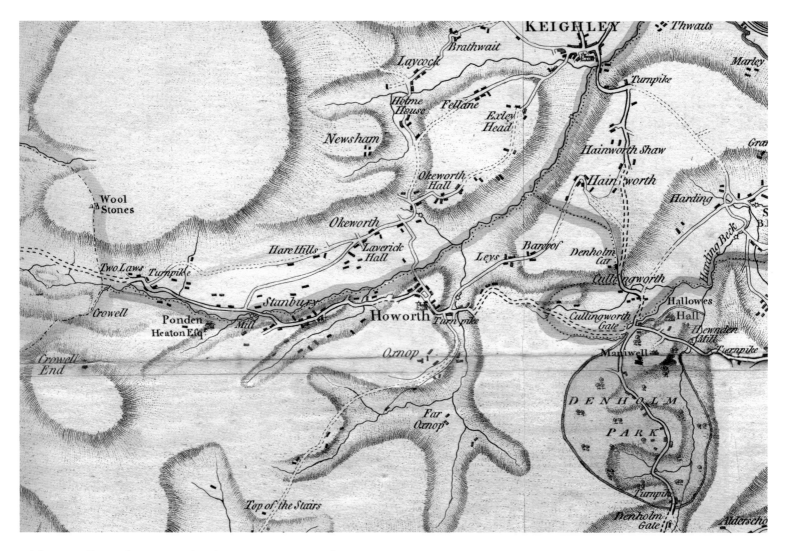

2. Thomas Jefferys, The County of York, 1771. (xi; 1" = 1 mile)

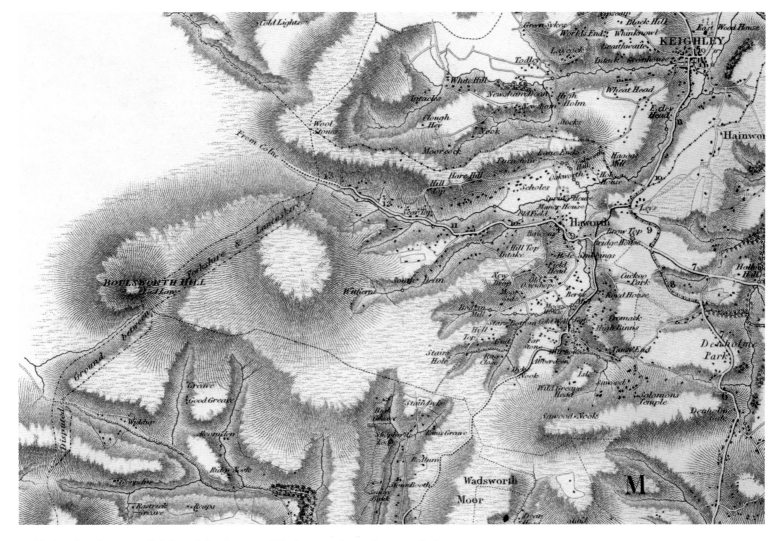

3. Christopher Greenwood, Map of the County of York, 1818. (xı; ı" = 1.4 miles)

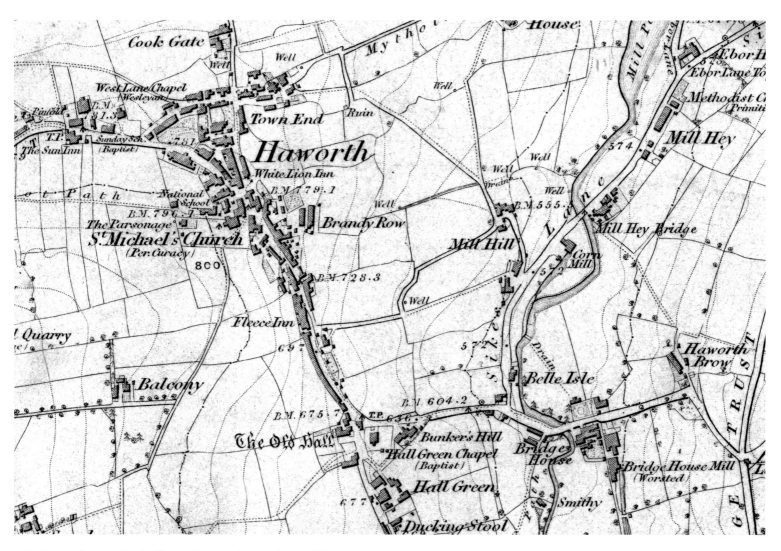

4. Ordnance Survey 6 inch, Haworth, 1852. (x2; 12" = 1 mile)

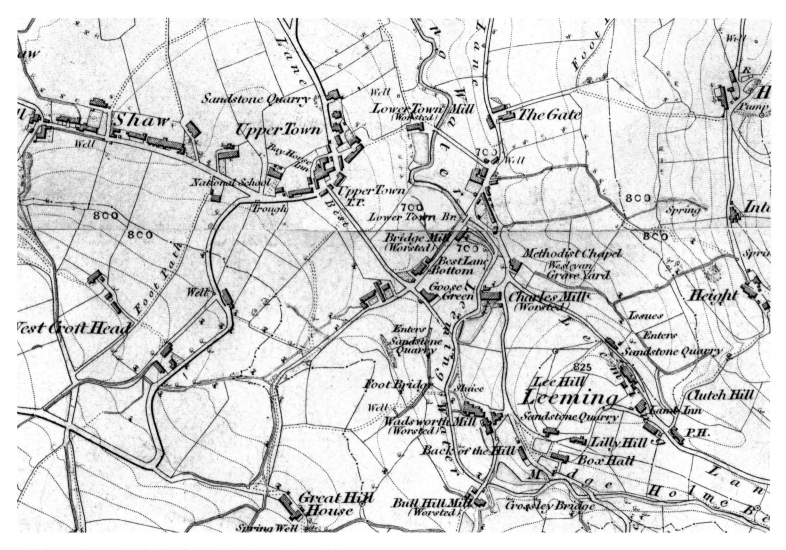

5. Ordnance Survey 6 inch, Oxenhope, 1852. (x2; 12" = 1 mile)

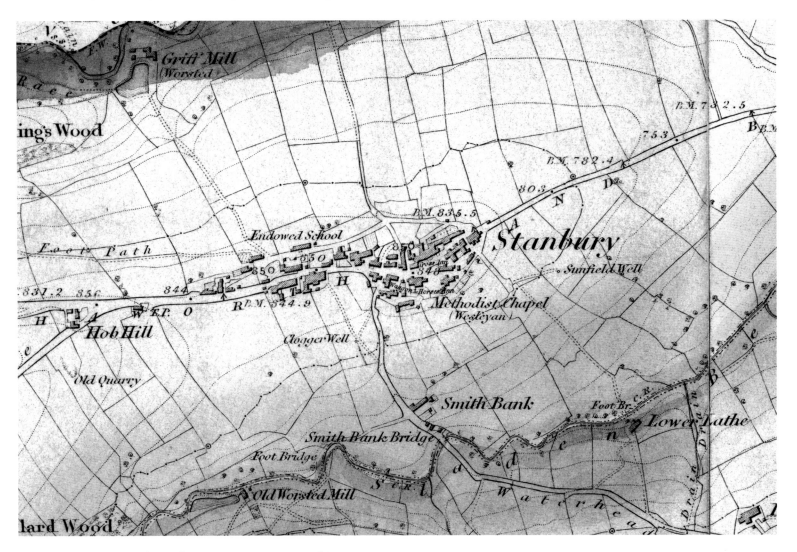

6. Ordnance Survey 6 inch, Stanbury, 1852. (x2; 12" = 1 mile)

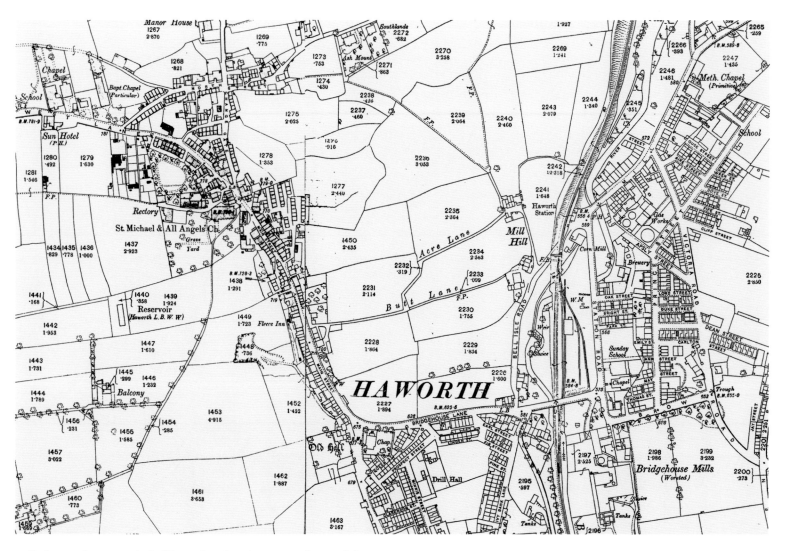

7. Ordnance Survey 25 inch, Haworth, 1894. (x0.5; 12.5" = 1 mile)

8. Ordnance Survey 25 inch, Oxenhope, 1894. (x0.5; 12.5" = 1 mile)

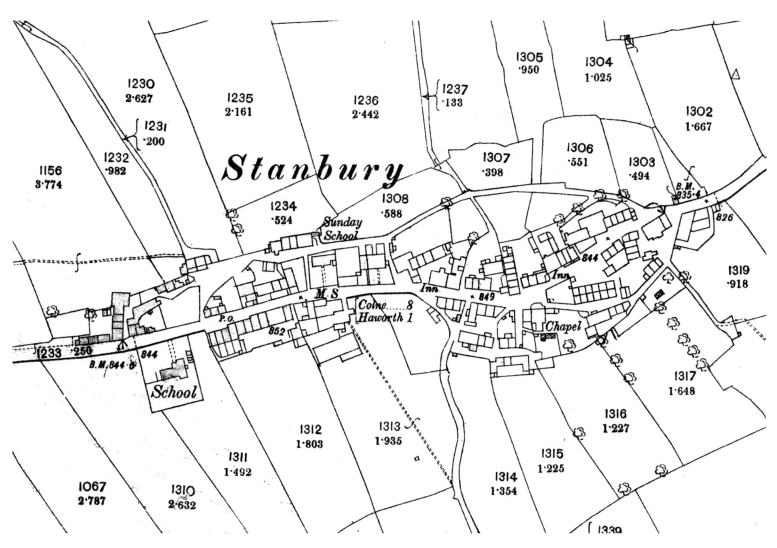

9. Ordnance Survey 25 inch, Stanbury, 1894. (XI; 25" = 1 mile)

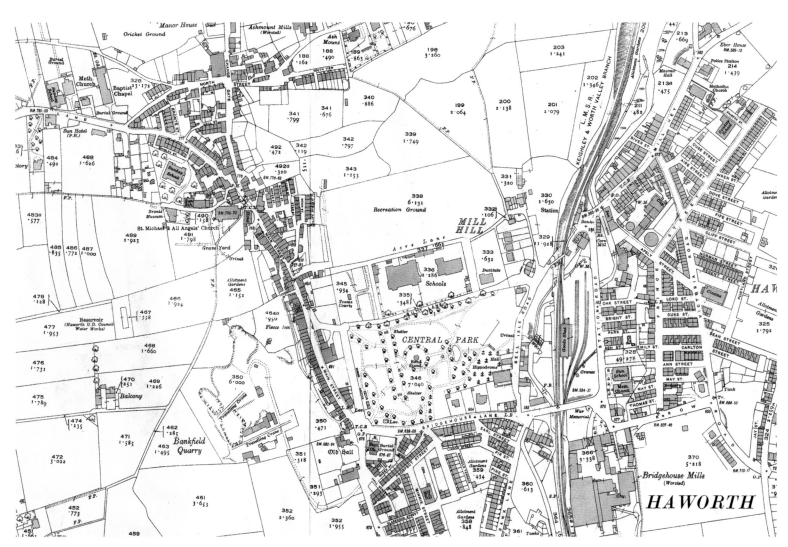

10. Ordnance Survey 25 inch, Haworth, 1934. (x0.5; 12.5" = 1 mile)

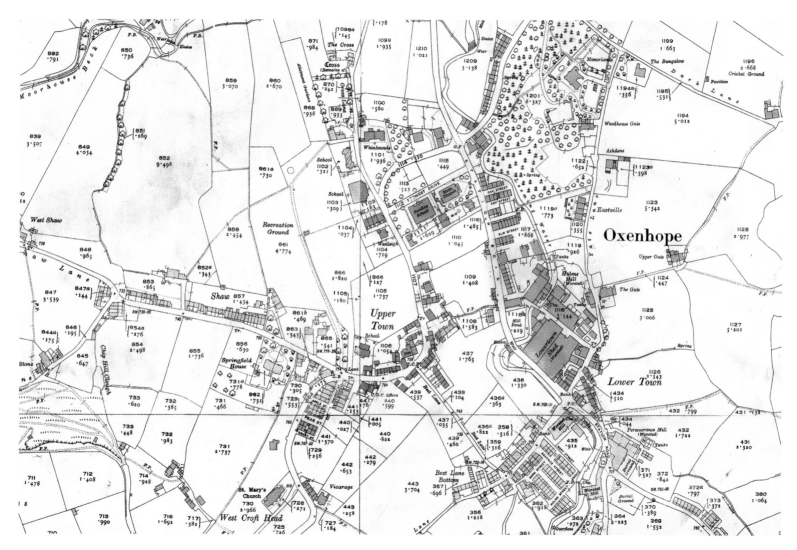

11. Ordnance Survey 25 inch, Oxenhope, 1934. (x0.5; 12.5″ = 1 mile)

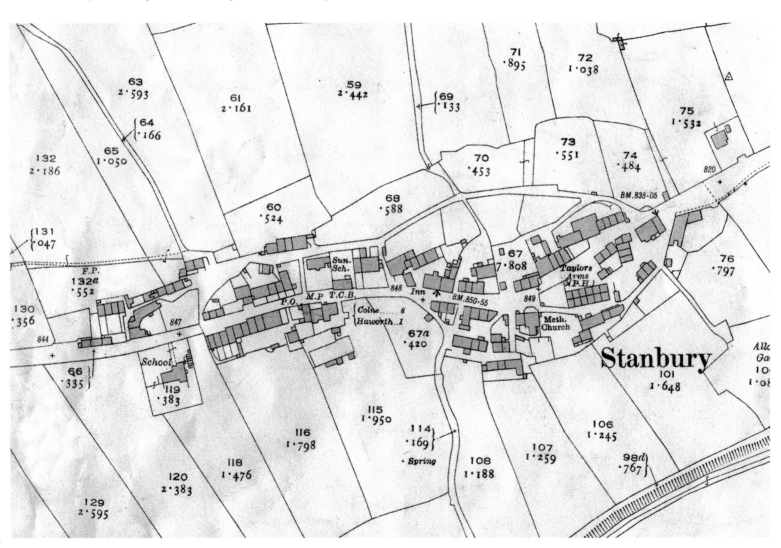

12. Ordnance Survey 25 inch, Stanbury, 1934. (xi; 25" = 1 mile)

BOARD OF HEALTH PLANS

One of Patrick Brontë's greatest achievements for his parish was the establishment of the Local Board of Health in 1851. It was Brontë who petitioned the General Board of Health to send an inspector to report on the sanitary condition of Haworth. The inspector who arrived in April 1850 was Benjamin Herschel Babbage, the son of Charles Babbage, inventor of the difference engine. The picture that Babbage's report drew was bad enough to ensure that a Local Board of Health was formed to see that Haworth was properly drained and provided with a sufficient supply of clean water.

Babbage's report was accompanied by two illustrations, both of which are reproduced here. One was a map of the district covered by the report. This was, effectively, the Hamlet of Haworth – one of the four subdivisions of the Township of Haworth. A small part of the Hamlet of Near Oxenhope is also on the map and some of this was, after further consideration, included in the Haworth Local Board area.

The other illustration shows the plan and rear elevation of the druggist's house at the top of Main Street. These were to illustrate one of the most striking passages in Babbage's report:

> In the main street opposite the Black Bull Inn, is a druggist's house; there are no back premises belonging to it, but immediately against the back wall of this house, there are coal-cellars, a privy and midden-stead, and a pigsty, used by some of the inhabitants of Gauger's Croft. I found that the night-soil from the privy emptied itself into a heap immediately below the druggist's larder window, while the pigsty was below the kitchen window. Upon inquiring at the druggist's house, I was informed that the contents of the midden-stead frequently came up as high as the sill of the larder window, and that 20 loads had been removed from it about three weeks previous to my visit. A woman, living in this house, said that she was always poorly and that the stench from the midden-stead and pigsty was so bad, that she frequently was not able to eat her meals. I have annexed a plan of these back premises, and a sketch of the back of the druggist's house, in order to show the position of the windows with reference to the midden-stead and pigsty.

One of the first acts of the newly formed Board was to commission a large-scale plan of the village for use in planning sewerage and water supply systems for Haworth. The surveyor employed to make this plan was Joseph Brierley of Burnley. The splendid plan that he drew is preserved at Keighley Local Studies Library. It is drawn at a scale of 10 feet to 1 mile and coloured to identify the building and road surfacing materials. Larger towns were surveyed by the OS at the 5 foot to the mile scale around this time – Brierley's plan more than makes up for Haworth's not qualifying for this treatment. The detail shown is amazing (and all relevant to its main purpose). Great attention is paid to levels – there are spot heights in red in almost every house. Every privy, ash place, rain spout, sewer grate and water supply is marked – it even shows kitchen sinks.

The whole plan is shown at a much reduced scale to give the overall picture and then, in four sections, at half the original scale to show the details. These are followed by the Babbage report map and his plan of the druggist's house.

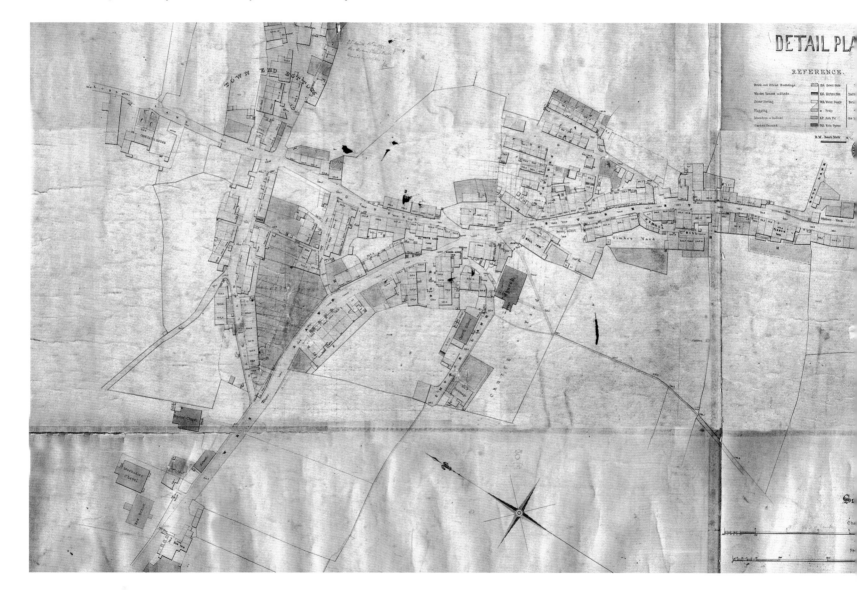

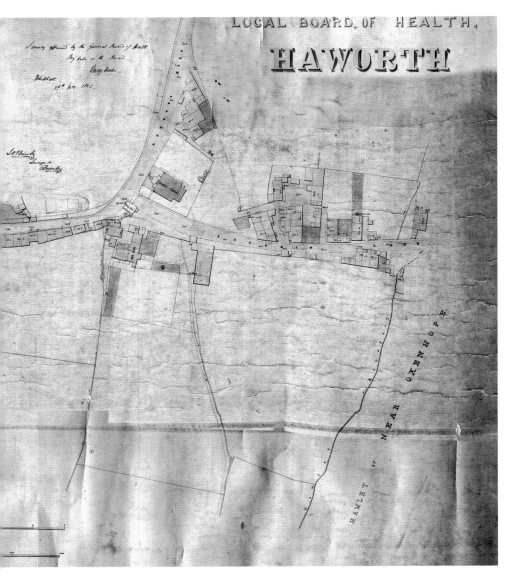

13. Haworth Local Board of Health plan, 1853. (x0.2; 25" = 1 mile)

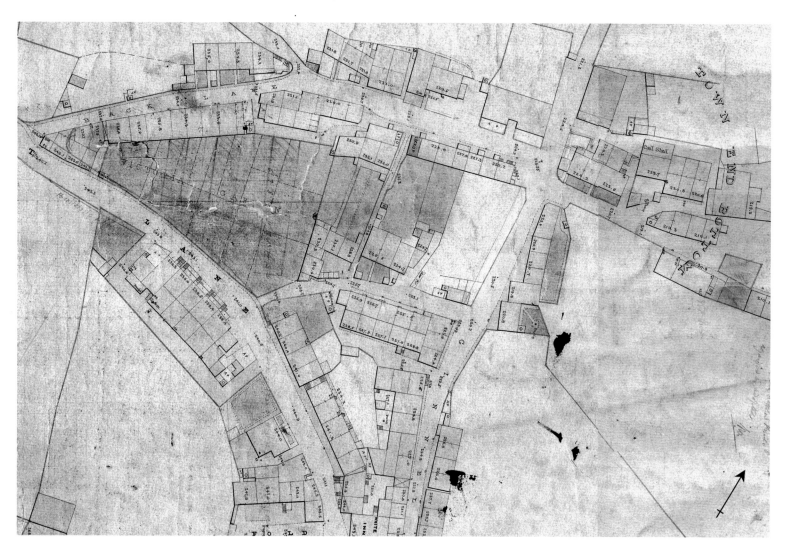

14. Haworth Local Board of Health plan, 1853, North Street. (x0.5; 60" = 1 mile)

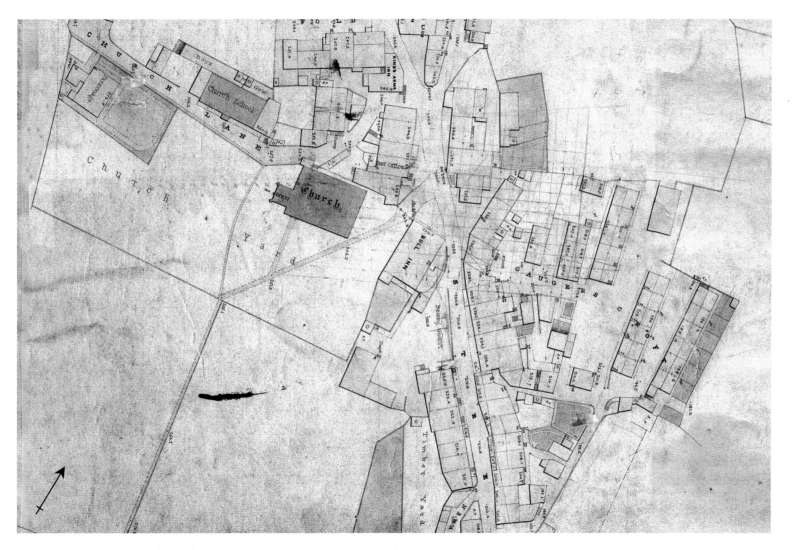

15. Haworth Local Board of Health plan, 1853, Church. (x0.5; 60" = 1 mile)

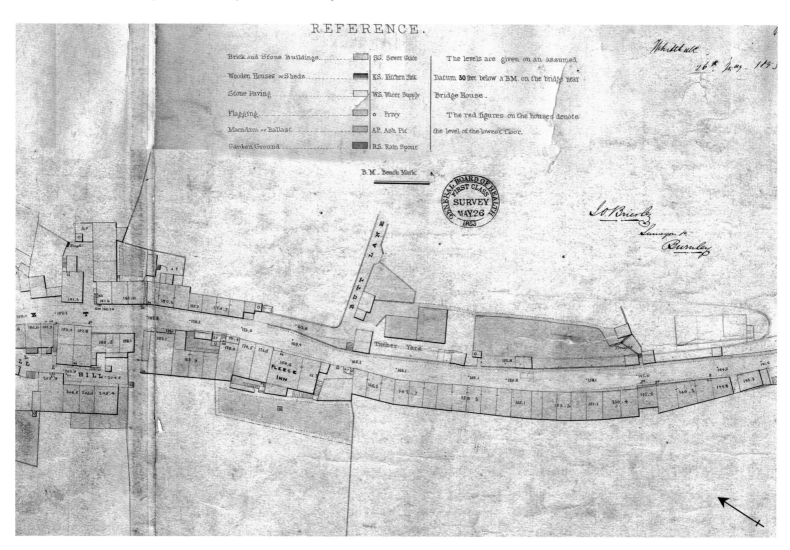

16. Haworth Local Board of Health, 1853, Main Street. (x0.5; 60" = 1 mile)

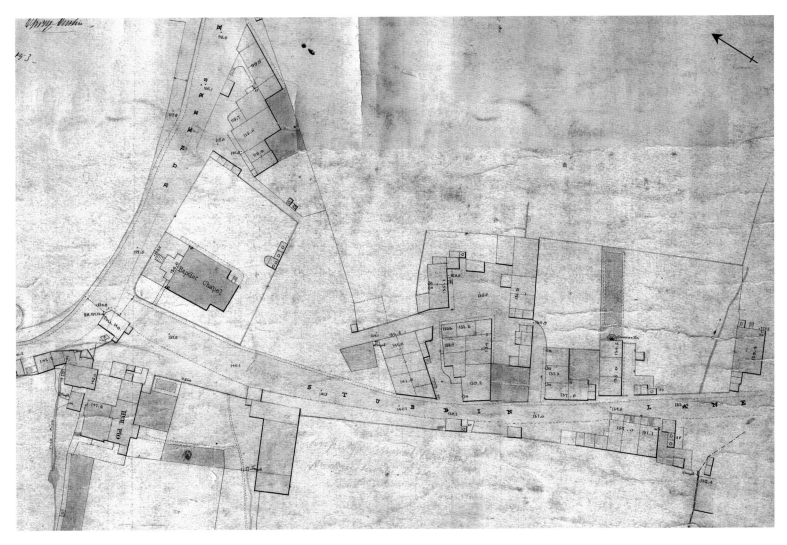

17. Haworth Local Board of Health, 1853, Sun Street. (x0.5; 60" = 1 mile)

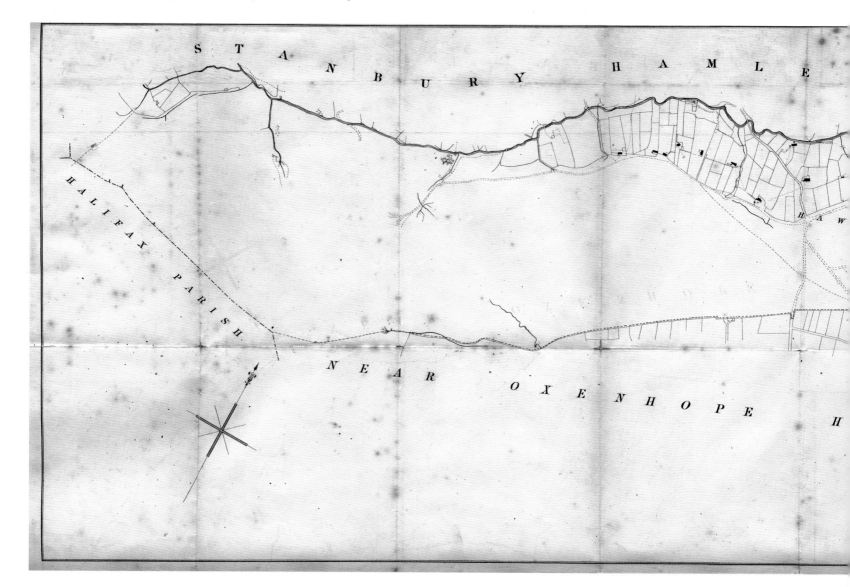

18. Babbage Report map, 1850.
(x0.5; 3" = 1 mile)

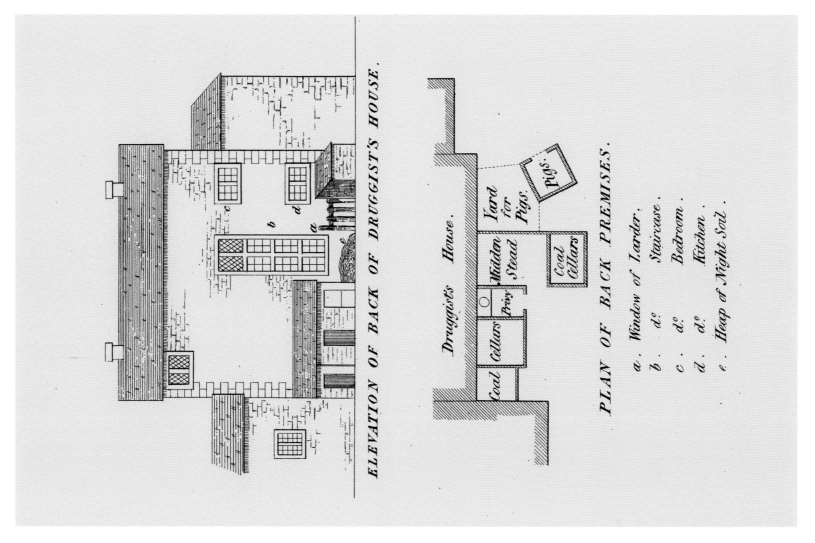

ELEVATION OF BACK OF DRUGGIST'S HOUSE.

PLAN OF BACK PREMISES.

a . Window of Larder.
b . d°. Staircase.
c . d°. Bedroom.
d . d°. Kitchen.
e . Heap of Night Soil.

19. Babbage Report, The Druggist's House, 1850. (x0.6)

THE HAWORTH TITHE MAP

The tithe maps are among the most important of all nineteenth-century sources for the local historian. An understanding of their origins is helpful when using them for local history research.

Tithes were a charge on the yield of the land, which went to the support of the clergy. Ten per cent of all agricultural produce was payable in kind – one sheaf of corn in ten, one calf, piglet or lamb in ten, one egg in ten and so on. Tithes were not payable on the products of industrial activity, although it was not unknown for a rector to claim tithes on lead mining as the lead was believed to 'grow' in the veins. There were generally two kinds of tithe and two people to whom they were payable: great tithes were payable to the rector and small tithes to the vicar. The former were the tithes of corn, hay and wood; the rest of the produce made up the small tithes.

There was growing dissatisfaction with the tithe system in the early nineteenth century. Tithes were seen to act as a brake on agricultural improvements, farmers being less willing to invest money when a tenth of any increased productivity was forfeit to those who contributed nothing to its production. A further source of discontent was the increasingly disproportionate burden on agriculture when the growing industrial sector was not laid under contribution. Furthermore, the payment of tithes in kind was a rich source of conflict between farmers and tithe owners.

As a result of these pressures and of fears of rural disquiet, or even riot, a bill for the commutation of tithes was passed in 1836. This provided for tithes to be paid in cash rather than kind. The amount to be paid was based on the assessed value of a property and varied with the average price of corn.

A detailed survey was needed to assess the rent charge that would be payable on each parcel of land. This survey produced two principal documents for each tithe district, the tithe map and the apportionment schedule.

The tithe maps varied a great deal in character and were divided into first- and second-class maps. The first-class maps received the seal of the Tithe Commissioners and had to meet demanding standards of accuracy. The second-class maps were a rather miscellaneous collection of old and new maps which in one way or another did not satisfy those standards. Only about one map in eight bears the tithe commissioners' seal denoting a first-class map.

First-class tithe maps are large-scale plans accurately showing field boundaries, roads, watercourses and buildings. They do not, however, carry the same amount of detail as a large-scale Ordnance Survey plan. Most importantly, every plot of land and, in some cases, every building on the map bears a unique number.

The apportionment is a document containing details of the various properties identified by the numbers on the tithe map. It gives information about the ownership, tenancy, name, state of cultivation, area and tithe liability of each individual field and, in some parishes, buildings. These entries are arranged in alphabetical order of the landowner's name.

There were three copies of each tithe award; the originals were retained by the Tithe Commissioners in London and statutory copies were made for the diocese and for the parish. The original documents are now deposited in the Public Record Office at Kew. Many diocesan and parish copies have found their way into local record offices. The diocesan copies of the Haworth award are in the Leeds office of West Yorkshire Archive Service,

the parish copy of the tithe map is in a private collection and is the one used here.

The vast majority of the 11,800 tithe awards had been completed by 1848. Haworth is an example of a rather late award, it having being made between 1849 and 1852.

The Haworth tithe map is a first-class map and consists of four large sheets, one for each of the constituent hamlets of the township: Haworth, Stanbury, Near Oxenhope and Far Oxenhope. The largest sheet is about 5 feet wide by 9 feet long. The scale of the maps is 3 chains to 1 inch. This was a common scale for estate maps and was the recommended scale for first-class tithe maps. It is equivalent to 26⅔ inches to the mile – a little larger than the Ordnance Survey 1:2500 plans.

The maps show field boundaries, woodland, streams and millponds, roads and paths and buildings in considerable detail. All plots of land and buildings have a tithe number. We are very fortunate that the Haworth tithe award is one of those that give details of buildings as well as land. The importance of this will be seen when we look at the house repopulation study.

The apportionment is a document made up of 163 parchment sheets about 21 by 19 inches. It includes details of nearly 3,500 numbered properties in the four hamlets. For each tithe number the following information is given: names of the owner and occupier, name or description of the property, extent in acres, roods and perches, tithes payable to the Vicar of Bradford and to the impropriate rector or to the landowners.

Haworth was then a chapelry in the parish of Bradford and the small tithes were thus payable to the Vicar of Bradford rather than to the perpetual curate of Haworth. The great tithes were mainly payable to the landowners, but on some few properties they were payable to the Revd Francis Dawson of Chislehurst in Kent, who was the impropriate rector for these lands. An impropriate rector was a layman to whom tithes were payable – in this case he happened to be a clergyman. It may cause some surprise that the great tithes were in large part payable to laymen. This is because tithes were property like any other and could be bequeathed or sold or otherwise transferred. Many tithes had passed into lay hands at the time of the Dissolution, monasteries having been important tithe owners.

As mentioned above, these extracts are from the parish copy of the tithe map; the extract from the apportionment is from the diocesan copy at Leeds archives. Comparison of the first two extracts with the 25 inch OS plans will show that the latter has rather more detail. The tithe map, however, gives us our earliest large-scale plan of the whole township. Its scale is a little larger than the 25 inch scale of the OS and the survey is forty years earlier than the first edition of that OS plan. Notice the depiction of the water supply arrangements of the Lower Town mills on the Oxenhope plan.

The third extract shows the buildings and land of a single farm – Mould Greave in Near Oxenhope. The apportionment shows that Mould Greave was among the properties belonging to Joseph Rushworth and that it was the one he lived in himself. I have shaded the land that was farmed by him in green and added the field names and state of cultivation from the apportionment. All the fields are either meadow or pasture; there is no arable land, as one would expect in a small dairy farm. The building at the bottom of the map labelled Fishers Lodge was a small water-powered textile mill owned by Rushworth.

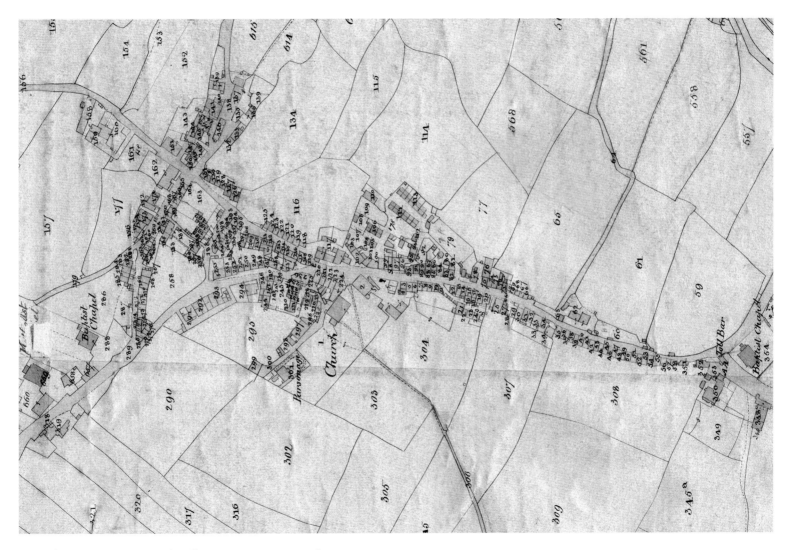

20. Tithe Map, 1850, Haworth Village. (x0.75; 20" = 1 mile)

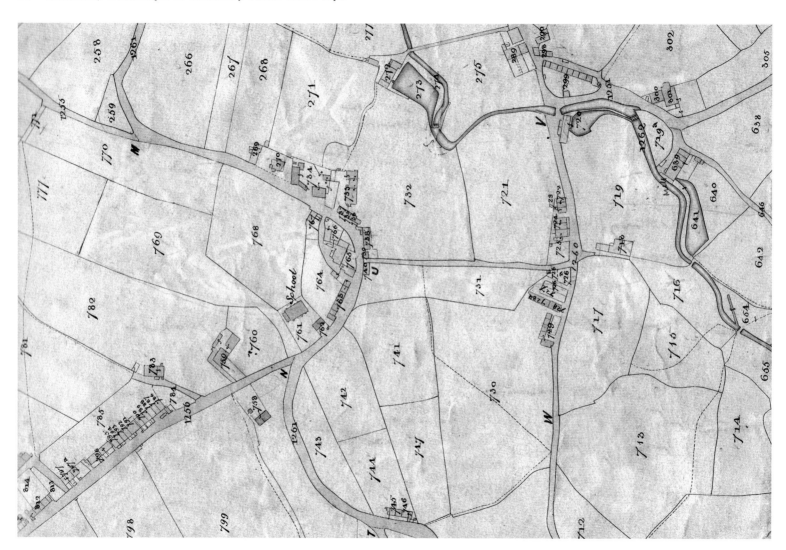

21. Tithe Map, 1850, Oxenhope Village. (x0.75; 20" = 1 mile)

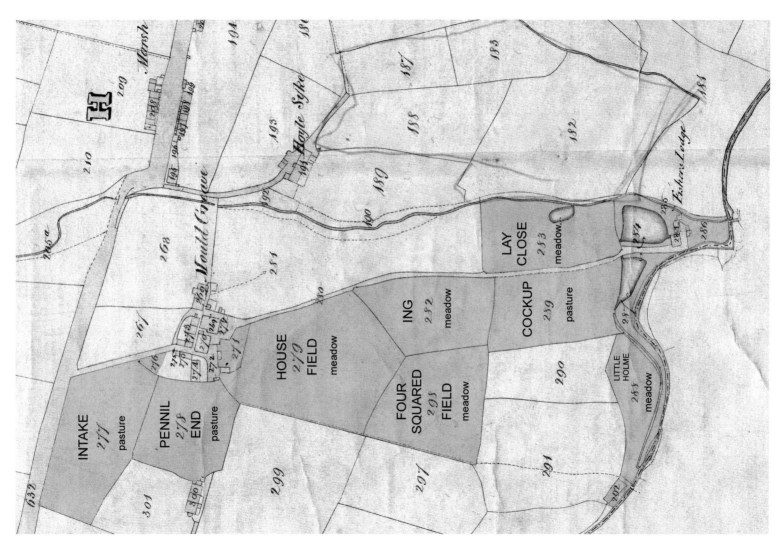

22. Tithe Map, 1850, Mould Greave. (x0.8; 21" = 1 mile)

Near Oxenhope Hamlet

C.—London: Printed and Published By Authority, by Shaw & Sons, Fetter Lane.

LANDOWNERS.	OCCUPIERS.	Numbers referring to the Plan.	NAME AND DESCRIPTION OF LANDS AND PREMISES.	STATE OF CULTIVATION.	QUANTITIES IN STATUTE MEASURE.			PAYABLE TO Vicar of Bradford			PAYABLE TO Landowners			REMARKS.
					A.	R.	P.	£	s.	d.	£	s.	d.	
Rushworth Joseph (continued)	Jonas Ratcliffe and another	50	House and Garden				11							
	John Sharp and another	49	House and Garden				6							
	Thomas Townend and others	48	Cottages and Buildings				6							
	Himself	274	House and Outbuildings				26							
		270					6							
		271	Fold Yards and Croft				26							
		272				1	6							
		320	Upper Stack	Pasture	1	3	21							
		276	Little Croft	Pasture			10			8				
		277	Intake	Pasture	1	3	25			4				
		278	Bernel End	Pasture	1	1	9			3				
		279	House Field	Meadow	2	2	34							
		280	Road				31		1	1				
		282	Ing	Meadow	1	1	26			5				
		283	Lay Close	Meadow	1	2	10			6				
		285	Plantation	Planted			30			1				
		286	Croft	Pasture			33			1				
		287		Pasture		2	8			1				
		288	Little Holme	Meadow		2	37			5				
		289	Cockup	Pasture	1	2	12							
		292	Plantation	Planted			11			4				
		293	Four squared Field	Meadow	1	2	32			5				
		318	Lower Stack	Pasture	1	3	28			2				
		319	Great do	Pasture	2	3	14			4				
		601	Allotment	Pasture	18	2	4			1				
					39	3	39		5			8		

23. Tithe Apportionment, 1853, Mould Greave.

HAWORTH VILLAGE HOUSE REPOPULATION PLAN

24–35. Repopulation Plan sections, 1851

The number given to each house in the Haworth tithe award allows us to look up the names of the owner and the occupier in the tithe apportionment. As the Haworth tithe award was made around 1850, there is a good match with the 1851 census returns. Using the location of a house and the tenant's name it is possible to identify the property in the census returns, which give details of all the inhabitants. In some cases the tithe award gives a single number to two or more houses and names only one of the tenants. We are very fortunate that there was a rating valuation done in 1851 that uses the tithe map as its reference map. The rating valuation gives us the names of those extra tenants who are not named in the tithe apportionment. By good fortune, the very large-scale Board of Health plan of Haworth village is also very close in date to the tithe award.

Taking these sources together it has been possible to produce a detailed plan showing who lived where in a large part of Haworth village in 1851. In each property the name of the tenant is written along with his or her occupation. There are also two reference numbers in most of the houses: the tithe number and the census household number. Where it has not been possible to find the household in the census only the tithe information is given.

To take an example, look at the block of houses at the junction of West Lane and North Street on the first plan. In the house at the junction we find William Parker, a power loom weaver. His house is No. 280 on the Haworth Hamlet tithe map. In the 1851 census he will be found in enumeration district 3, household No. 57. Looking in the census returns we find that he was thirty-six years old and was born in Thornton. His wife was Hannah, a twenty-six-year-old power loom weaver born in Stanbury. There were two children: Betty, aged five, and Edward, aged two. Both were born in Haworth and are described as 'scholars'.

Looking up the tithe number in the apportionment tells us that William Parker's house was owned by William Turner. Turner also owned the other six cottages in this block and his own house near The Fold.

Returning to the seven cottages at the end of North Street it will be seen that I have only managed to identify three of them in the census – the other four have only the tithe number and name.

In cases where there is a difference between the name given in the tithe award and the name given in the census returns, the census name is given in (brackets). This has only been done where it is possible to be confident that the named person lived in the property.

It may take a while to get used to finding particular places in these plans. I have added north arrows and street names as a guide. Current street names are shown in **ARIAL BOLD**. Where the street name was different in 1851 the old name is added in ***ARIAL BOLD ITALIC***. The names of streets that have been demolished are also shown in ***ARIAL BOLD ITALIC***.

The spelling Guager's Croft (30), rather than the more normal Gauger's, is the one commonly used in records of the period. This area was also known as Brandy Row and, more recently, Piccadilly.

The overall Board of Health plan (map 13) should help with finding particular places on these plans.

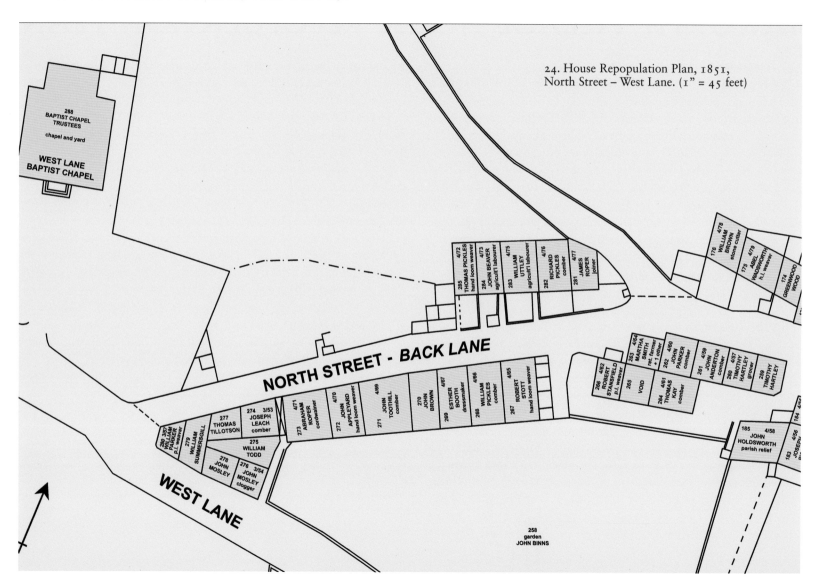

24. House Repopulation Plan, 1851,
North Street – West Lane. (1" = 45 feet)

288
BAPTIST CHAPEL
TRUSTEES

chapel and yard

WEST LANE
BAPTIST CHAPEL

WEST LANE

NORTH STREET - BACK LANE

285
THOMAS PICKLES
hand loom weaver
4/72

4/73
284
JOHN BEAVER
agricul'l labourer

4/75
283
WILLIAM
UTTLEY
agricul'l labourer

4/76
282
RICHARD
PICKLES
comber

4/77
281
JAMES
ROPER
joiner

176
WILLIAM
BROWN
stone cutter
4/78

4/79
175
ABEL
WADSWORTH
h.l. weaver

174
GREENWOOD
WOOD

280 3/57
WILLIAM
PARKER
p.l. weaver

279
WILLIAM
SUMMERSGILL

277
THOMAS
TILLOTSON

274 3/53
JOSEPH
LEACH
comber

275
WILLIAM
TODD

278
JOHN
MOSLEY

276 3/54
JOHN
MOSLEY
clogger

273
ABRAHAM
ROPER
cordwainer
4/71

4/70
272
JOHN
APPLEYARD
hand loom weaver

4/69
271
JOHN
TOOTHILL
comber

270
JOHN
BROWN

4/67
269
ESTHER
BOOTH
dressmaker

4/66
268
WILLIAM
PICKLES
comber

4/65
267
ROBERT
STOTT
hand loom weaver

266 4/62
ROBERT
STANSFIELD
p.l. weaver

265
VOID

263
MARTHA
SMITH
ret. farmer
+1 other
4/63

262
JOHN
PARKER
comber
4/60

264
THOMAS
KAY
comber
4/61

261
JOHN
ANDERTON
comber
4/59

260
TIMOTHY
HARTLEY
grocer
4/57

259
TIMOTHY
HARTLEY

185
JOHN
HOLDSWORTH
parish relief
4/58

183

4/56

184

JOSEPH

258
garden
JOHN BINNS

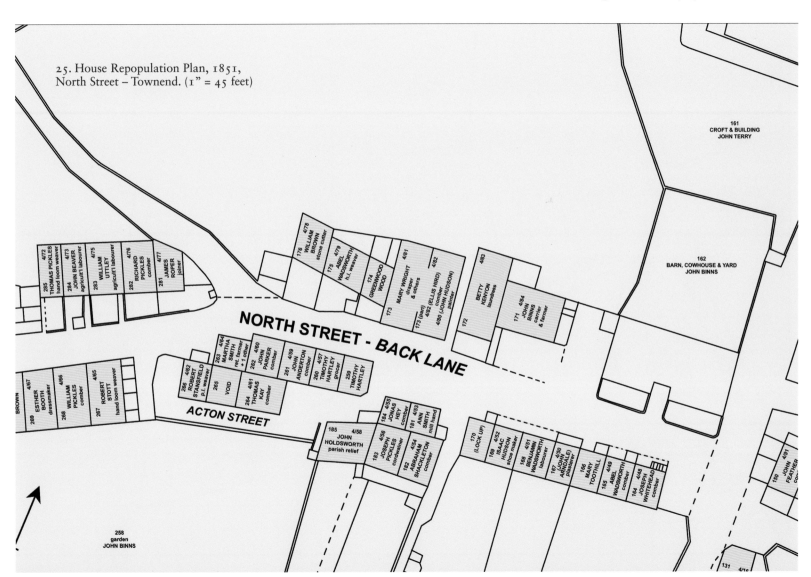

25. House Repopulation Plan, 1851,
North Street – Townend. (1" = 45 feet)

161
CROFT & BUILDING
JOHN TERRY

162
BARN, COWHOUSE & YARD
JOHN BINNS

NORTH STREET - BACK LANE

ACTON STREET

BROWN

472
285
THOMAS PICKLES
hand loom weaver

473
284
JOHN BEAVER
agricul'l labourer

475
283
WILLIAM
UTTLEY
agricul't labourer

476
282
RICHARD
PICKLES
comber

477
281
JAMES
ROPER
joiner

478
176
WILLIAM
BROWN
stone cutter

479
175
ABEL
WADSWORTH
h.l weaver

174
173
GREENWOOD
WOOD

461
4/61
MARY WRIGHT
draper
& others

462
4/82 (part)
4/82 (ELLIS HIRD)
comber
480 (JOHN HUDSON)
painter

172

463
4/83

171
4/84
JOHN
BINNS
carrier
& farmer

BETTY
KENYON
laundress

464
263
MARTHA
SMITH
ret. farmer
+ 1 other

460
262
JOHN
PARKER
comber

459
261
JOHN
ANDERTON
comber

457
260
TIMOTHY
HARTLEY
grocer

259
TIMOTHY
HARTLEY

462
266
ROBERT
STANSFIELD
p.l weaver

461
264
THOMAS
KAY
comber

265
VOID

467
269
ESTHER
BOOTH
dressmaker

466
268
WILLIAM
PICKLES
comber

465
267
ROBERT
STOTT
hand loom weaver

455
184
JONAS
HEY
comber

453
181
ANN
SMITH
mill hand

4/58
185
JOHN
HOLDSWORTH
parish relief

456
183
JOSEPH
PICKLES
cordwainer

454
182
ABRAHAM
SHACKLETON
comber

170
(LOCK UP)

452
169
ISAAC
HUDSON
shoe maker

451
168
BENJAMIN
WADSWORTH
labourer

450
167
(JOHN
ARNDALE)
plasterer

166
MARY,
TOOTHILL

449
165
ABEL
WADSWORTH
comber

448
164
JOSEPH
WHITEHEAD
comber

150
JOHN
FEATHER

491
JOHN
comber

258
garden
JOHN BINNS

131
4/16

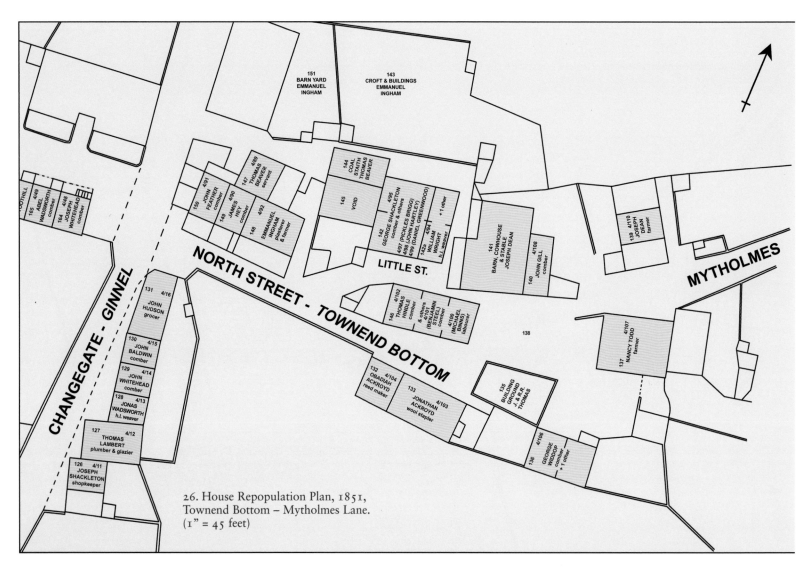

151
BARN YARD
EMMANUEL
INGHAM

143
CROFT & BUILDINGS
EMMANUEL
INGHAM

165
ABEL
WADSWORTH
comber

4/49

164
JOSEPH
WHITEHEAD
comber

4/48

149
JOHN
FEATHER
comber

4/91

150

147
THOMAS
BEAVER
servant

4/89

149
JAMES
HEY
comber

4/90

148
EMMANUEL
INGHAM
plasterer
& farmer

4/92

144
COAL
STATH
THOMAS
BEAVER

145
VOID

142
GEORGE SHACKLETON
comber & others

4/95

4/97 (PICKLES BRIGG)
4/98 (JOHN HARTLEY)
4/99 (DANIEL GREENWOOD)

494
WILLIAM
WRIGHT

142a
h.l. weaver

+1 other

LITTLE ST.

141
BARN, COWHOUSE
& STABLE
JOSEPH DEAN

4/110
JOSEPH
DEAN
farmer

139

4/108
JOHN GILL
comber

140

MYTHOLMES

CHANGEGATE - GINNEL

NORTH STREET - TOWNEND BOTTOM

131 4/16
JOHN
HUDSON
grocer

130 4/15
JOHN
BALDWIN
comber

129 4/14
JOHN
WHITEHEAD
comber

128 4/13
JONAS
WADSWORTH
h.l. weaver

127 4/12
THOMAS
LAMBERT
plumber & glazier

126 4/11
JOSEPH
SHACKLETON
shopkeeper

146
THOMAS
HINDLE
comber
& others

4/102

4/101
(BENJAMIN
STEEL)

4/100
(MICHAEL
BINNS)
labourer

138

132 4/104
OBADIAH
ACKROYD
reed maker

133 4/103
JONATHAN
ACKROYO
wool stapler

135
BUILDING
GROUND
J. & R.R.
THOMAS

136 4/106
GEORGE
WIDDOP
comber
+ 1 other

137
4/107
NANCY TODD
farmer

26. House Repopulation Plan, 1851,
Townend Bottom – Mytholmes Lane.
(1" = 45 feet)

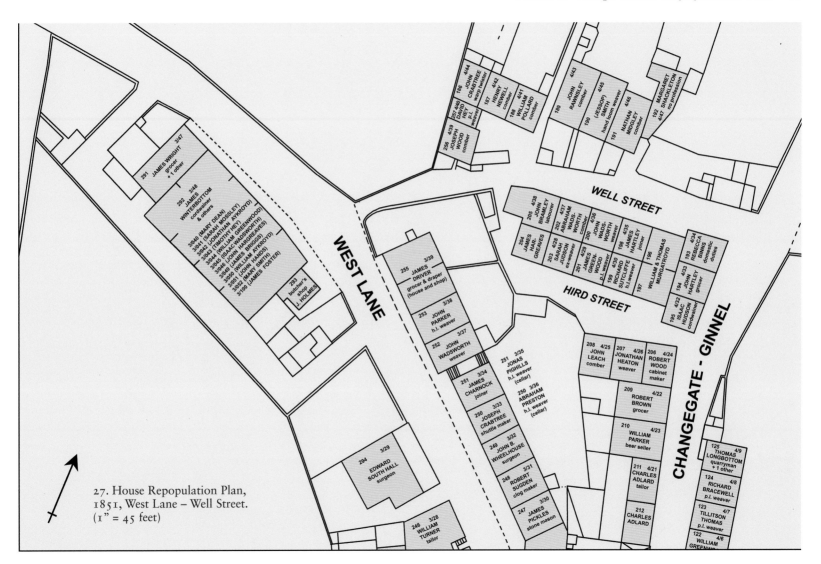

27. House Repopulation Plan,
1851, West Lane – Well Street.
(1" = 45 feet)

WEST LANE

291 3/47 JAMES WRIGHT grocer + 1 other
292 3/48 JAMES WINTERBOTTOM cordwainer & others
3/040 (MARY DEAN)
3/042 (SARAH MOSSLEY)
3/043 (TIMOTHY HEY)
3/044 (JONATHAN AYKROYD)
3/045 (WILLIAM GREENWOOD)
3/046 (ISAAC HARGREAVES)
3/048 (JOHN HANDS)
3/049 (JAMES BRIGGS)
3/050 (WILLIAM AYKROYD)
3/051 (JOHN SMITH)
3/052 (MARY SMITH)
3/100 (JAMES FOSTER)

butcher's shop J. HOLMES
293

WEST LANE

255 3/39 JAMES DRIVER grocer & draper (house and shop)
253 3/38 JOHN PARKER h.l. weaver
252 3/37 JOHN WADSWORTH weaver
251 3/34 JAMES CHARNOCK joiner
250 3/33 JOSEPH CRABTREE shuttle maker
249 3/32 JOHN B. WHEELHOUSE surgeon
248 3/31 ROBERT SUGDEN clog maker
247 3/30 JAMES PICKLES stone mason
246 3/28 WILLIAM TURNER tailor

294 3/29 EDWARD SOUTH HALL surgeon

251 3/35 JONAS PIGHILLS h.l. weaver (cellar)
250 3/36 ABRAHAM PRESTON h.l. weaver (cellar)

186 4/44 JOHN CRABTREE warp twister
257 4/40 DAVID HEY h.l.
187 4/42 HENRY NEWELL comber
188 4/41 WILLIAM POLLARD
256 4/39 JOSEPH WOOD comber

189 4/43 JOHN RAWNSLEY comber
4/45 (JESSOP) hand loom weaver
190
191 4/46 NATHAN MIDGLEY comber
192 4/47 MARGARET SHACKLETON no profession

WELL STREET

205 4/38 JOHN BRAMLEY labourer
204 JAMES HAR-GREAVES
202 4/37 ABRAHAM WADS-WORTH comber
203 4/28 SARAH JUDSON ex-weaver
201 4/29 JAMES GREEN-WOOD
200 4/30 JAMES GREEN-WOOD p.l. weaver
199 RICHARD SUTCLIFFE h.l. weaver
198 4/35 JAMES HARTLEY joiner
196 WILLIAM & THOMAS MURGATROYD
197 4/33 JOHN HARTLEY grocer
4/32 194
195 ISAAC HUDSON cordwainer
193 4/34 REBECCA BINNS domestic duties
4/36 JOHN WADS-WORTH weaver

HIRD STREET

208 4/25 JOHN LEACH comber
207 4/26 JONATHAN HEATON weaver
206 4/24 ROBERT WOOD cabinet maker
209 4/22 ROBERT BROWN grocer
210 4/23 WILLIAM PARKER beer seller
211 4/21 CHARLES ADLARD tailor
212 CHARLES ADLARD

125 4/9 THOMAS LONGBOTTOM quarryman + 1 other
124 4/8 RICHARD BRACEWELL p.l. weaver
123 4/7 TILLITSON THOMAS p.l. weaver
122 4/6 WILLIAM GREENING

CHANGEGATE - GINNEL

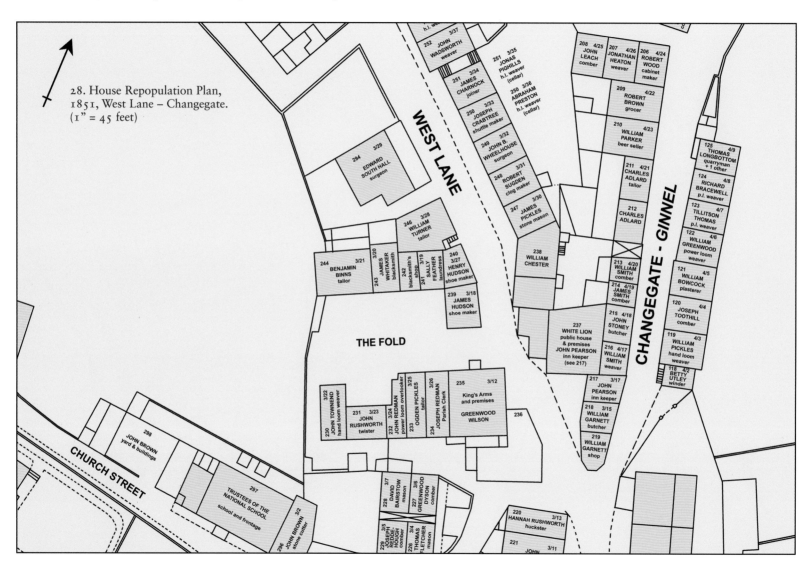

28. House Repopulation Plan, 1851, West Lane – Changegate. (1" = 45 feet)

WEST LANE

CHANGEGATE - GINNEL

CHURCH STREET

THE FOLD

252 3/37
JOHN WADSWORTH
weaver

251 3/34
JAMES CHARNOCK
joiner

250 3/33
JOSEPH CRABTREE
shuttle maker

249 3/32
JOHN B. WHEELHOUSE
surgeon

248 3/31
ROBERT SUGDEN
clog maker

247 3/30
JAMES PICKLES
stone mason

251 3/35
JONAS PIGHILLS
h.l. weaver (cellar)

250 3/36
ABRAHAM PRESTON
h.l. weaver (cellar)

208 4/25
JOHN LEACH
comber

207 4/26
JONATHAN HEATON
weaver

206 4/24
ROBERT WOOD
cabinet maker

209 4/22
ROBERT BROWN
grocer

210 4/23
WILLIAM PARKER
beer seller

211 4/21
CHARLES ADLARD
tailor

212
CHARLES ADLARD

125 4/9
THOMAS LONGBOTTOM
quarryman + 1 other

124 4/8
RICHARD BRACEWELL
p.l weaver

123 4/7
TILLITSON THOMAS
p.l weaver

122 4/6
WILLIAM GREENWOOD
power loom weaver

121 4/5
WILLIAM BOWCOCK
plasterer

120 4/4
JOSEPH TOOTHILL
comber

119 4/3
WILLIAM PICKLES
hand loom weaver

118 4/2
BETTY UTLEY
winder

294 3/29
EDWARD SOUTH HALL
surgeon

246 3/28
WILLIAM TURNER
tailor

244 3/21
BENJAMIN BINNS
tailor

243 3/20
JAMES WHITAKER
blacksmith

242 3/19
blacksmith's shop

241
SALLY FEATHER
laundress

240 3/27
HENRY HUDSON
shoe maker

239 3/18
JAMES HUDSON
shoe maker

238
WILLIAM CHESTER

213 4/20
WILLIAM SMITH
comber

214 4/19
JAMES SMITH
comber

215 4/18
JOHN STONEY
butcher

216 4/17
WILLIAM SMITH
weaver

237
WHITE LION
public house & premises
JOHN PEARSON
inn keeper
(see 217)

217 3/17
JOHN PEARSON
inn keeper

218 3/15
WILLIAM GARNETT
butcher

219
WILLIAM GARNETT
shop

230 3/22
JOHN TOWNEND
hand loom weaver

231 3/23
JOHN RUSHWORTH
twister

232 3/24
JOHN REDMAN
power loom overlooker

233
OGDEN PICKLES
tailor

234 3/26
JOSEPH REDMAN
Parish Clerk

235 3/12
King's Arms and premises
GREENWOOD WILSON

236

298
JOHN BROWN
yard & buildings

297
TRUSTEES OF THE NATIONAL SCHOOL
school and frontage

296 3/2
JOHN BROWN
stone cutter

228 3/7
DAVID BAIRSTOW
mason

227 3/6
GREENWOOD DYSON
comber

229 3/5
JOSEPH RIDEHOUGH
comber

230 3/4
THOMAS FLETCHER
mason

220 3/13
HANNAH RUSHWORTH
huckster

221 3/11
JOHN

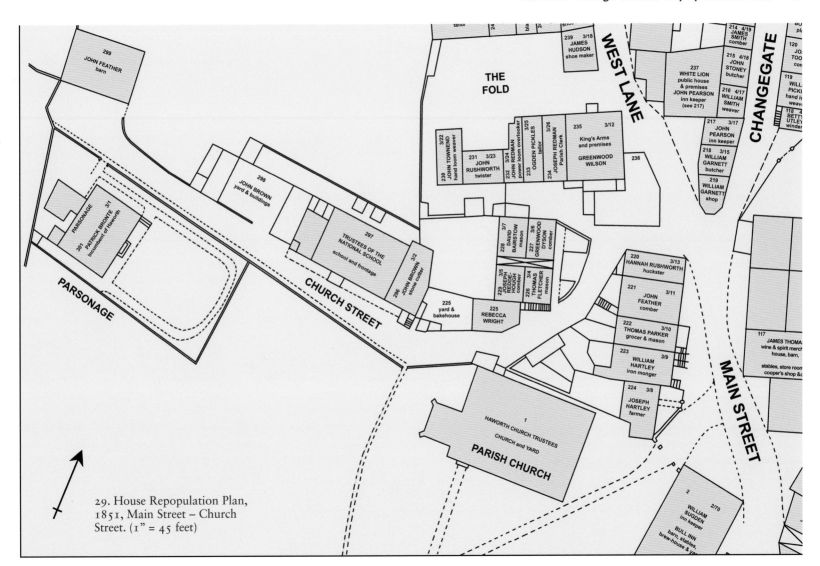

299
JOHN FEATHER
barn

THE
FOLD

WEST LANE

CHANGEGATE

239 3/18
JAMES
HUDSON
shoe maker

tailor

214 4/19
JAMES
SMITH
comber

120
JO
TOO
co

237
WHITE LION
public house
& premises
JOHN PEARSON
inn keeper
(see 217)

215 4/18
JOHN
STONEY
butcher

119
WILL
PICKL
hand l
weave

216 4/17
WILLIAM
SMITH
weaver

118
BETTY
UTLEY
winde

217 3/17
JOHN
PEARSON
inn keeper

218 3/15
WILLIAM
GARNETT
butcher

219
WILLIAM
GARNETT
shop

298
JOHN BROWN
yard & buildings

3/22
230
JOHN TOWNEND
hand loom weaver

231 3/23
JOHN
RUSHWORTH
twister

3/24
232
JOHN REDMAN
power loom overlooker
comber

3/25
233
OGDEN PICKLES
tailor

3/26
234
JOSEPH REDMAN
Parish Clerk

235 3/12
King's Arms
and premises
GREENWOOD
WILSON

236

PARSONAGE

301
PATRICK BRONTE
Incumbent of Haworth

3/1
PARSONAGE

297
TRUSTEES OF THE
NATIONAL SCHOOL
school and frontage

3/7
228
DAVID
BAIRSTOW
mason

3/6
227
GREENWOOD
DYSON
comber

3/2
296
JOHN BROWN
stone cutter

CHURCH STREET

3/5
229
JOSEPH
RIDDE-
HOUGH
comber

3/4
226
THOMAS
FLETCHER
mason

225
yard &
bakehouse

225
REBECCA
WRIGHT

220 3/13
HANNAH RUSHWORTH
huckster

221 3/11
JOHN
FEATHER
comber

222 3/10
THOMAS PARKER
grocer & mason

223 3/9
WILLIAM
HARTLEY
iron monger

224 3/8
JOSEPH
HARTLEY
farmer

117
JAMES THOMA
wine & spirit merch
house, barn,
stables, store room
cooper's shop & c

MAIN STREET

1
HAWORTH CHURCH TRUSTEES
CHURCH and YARD

PARISH CHURCH

2
WILLIAM
SUGDEN
inn keeper
BULL INN
barn, stables,
brew-house & ya

2/70

29. House Repopulation Plan,
1851, Main Street – Church
Street. (1" = 45 feet)

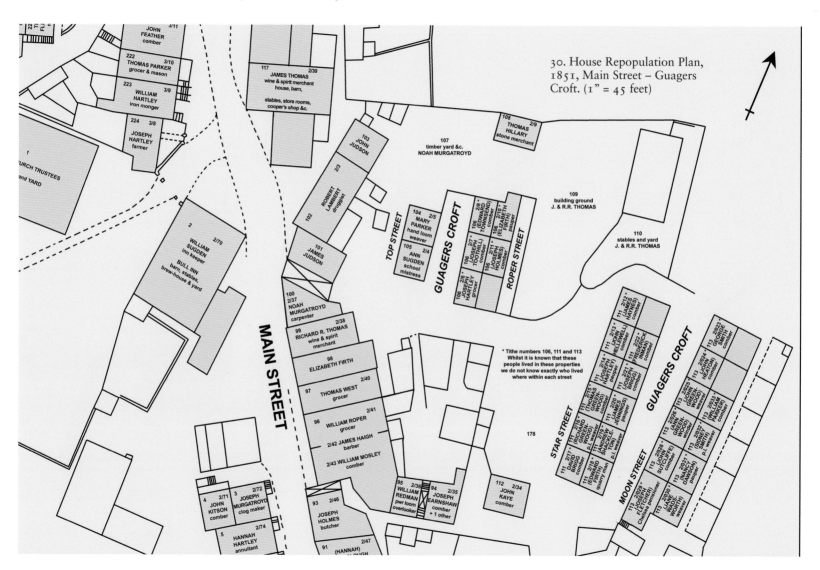

30. House Repopulation Plan, 1851, Main Street – Guagers Croft. (1" = 45 feet)

* Tithe numbers 106, 111 and 113 Whilst it is known that these people lived in these properties we do not know exactly who lived where within each street

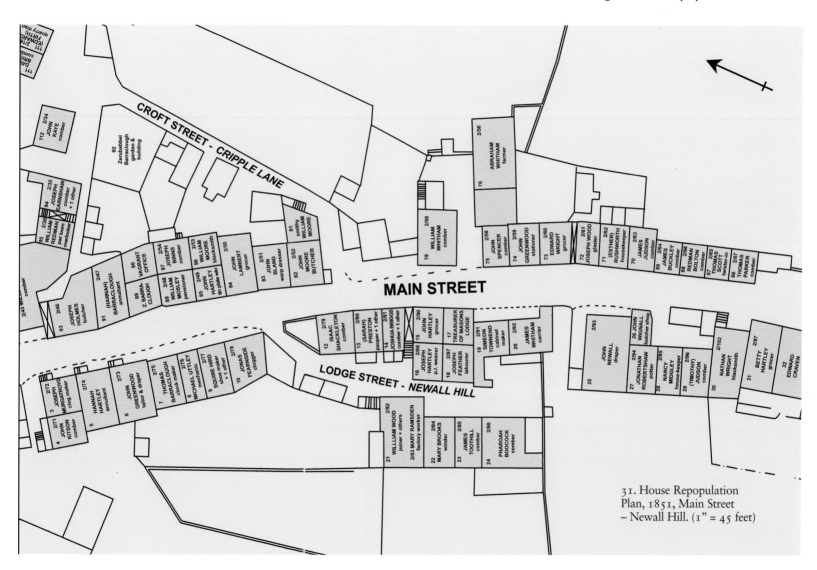

31. House Repopulation
Plan, 1851, Main Street
– Newall Hill. (1" = 45 feet)

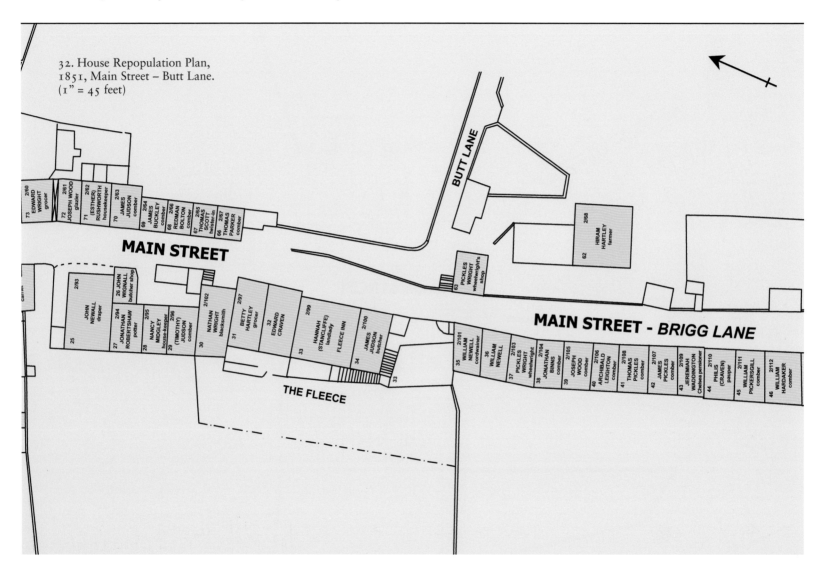

32. House Repopulation Plan,
1851, Main Street – Butt Lane.
(1" = 45 feet)

BUTT LANE

MAIN STREET

MAIN STREET - BRIGG LANE

THE FLEECE

2/60 73 EDWARD WRIGHT grocer
2/61 72 JOSEPH WOOD glazier
2/62 71 (ESTHER) RUSHWORTH housekeeper
2/63 70 JAMES JUDSON comber
2/64 69 JAMES BUCKLEY comber
2/66 68 REDMAN BOLTON comber
2/65 67 THOMAS SCOTT twister-in
2/67 66 THOMAS PARKER comber

2/68 62 HIRAM HARTLEY farmer

2/93 25 JOHN NEWALL draper
26 JOHN WIGNALL butcher shop
2/94 27 JONATHAN ROBERTSHAW potter
2/95 28 NANCY MIDGLEY house-keeper
2/96 29 (TIMOTHY) JUDSON comber
2/102 30 NATHAN WRIGHT blacksmith
2/97 31 BETTY HARTLEY grocer
2/98 32 EDWARD CRAVEN
2/99 33 HANNAH (STANCLIFFE) landlady FLEECE INN
2/100 34 JAMES JUDSON butcher
33

63 PICKLES WRIGHT wheelwright's shop

35 2/101 WILLIAM NEWELL cordwainer
36 2/102 WILLIAM NEWELL
37 2/103 PICKLES WRIGHT wheelwright
38 2/104 JONATHAN BINNS comber
39 2/105 JOSEPH WOOD comber
40 2/106 ARCHIBALD LEIGHTON comber
41 2/108 THOMAS PICKLES comber
42 2/107 JAMES PICKLES comber
43 2/109 JEREMIAH WADDINGTON Chelsea pensioner
44 2/110 PHILIS (CRAVEN) pauper
45 2/111 WILLIAM PICKERSGILL comber
46 2/112 WILLIAM HARDAKER comber

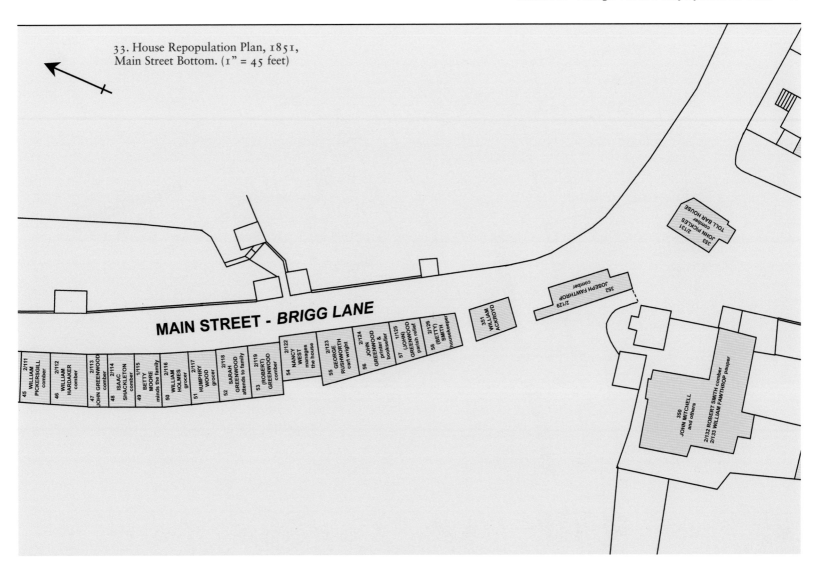

33. House Repopulation Plan, 1851,
Main Street Bottom. (1" = 45 feet)

MAIN STREET - BRIGG LANE

45 2/111 WILLIAM PICKERSGILL comber

46 2/112 WILLIAM HARDAKER comber

47 2/113 JOHN GREENWOOD comber

48 2/114 ISAAC SHACKLETON comber

49 1/115 BETTY MOORE minds the family

50 2/116 WILLIAM HOLMES grocer

51 2/117 HUMPHRY WOOD grocer

52 2/118 SARAH GREENWOOD attends to family

53 2/119 (ROBERT) GREENWOOD comber

54 2/122 NANCY WEST manages the house

55 2/123 GEORGE RUSHWORTH cart wright

56 2/124 JOHN GREENWOOD printer & bookseller

57 1/125 (JOHN) GREENWOOD parish relief

58 2/126 (BETTY) SMITH housekeeper

351 WILLIAM ACKROYD

352 2/129 JOSEPH FAWTHROP comber

353 2/131 JOHN PICKLES comber TOLL BAR HOUSE

350 JOHN MITCHELL and others 2/132 ROBERT SMITH comber 2/133 WILLIAM FAWTHROP pauper

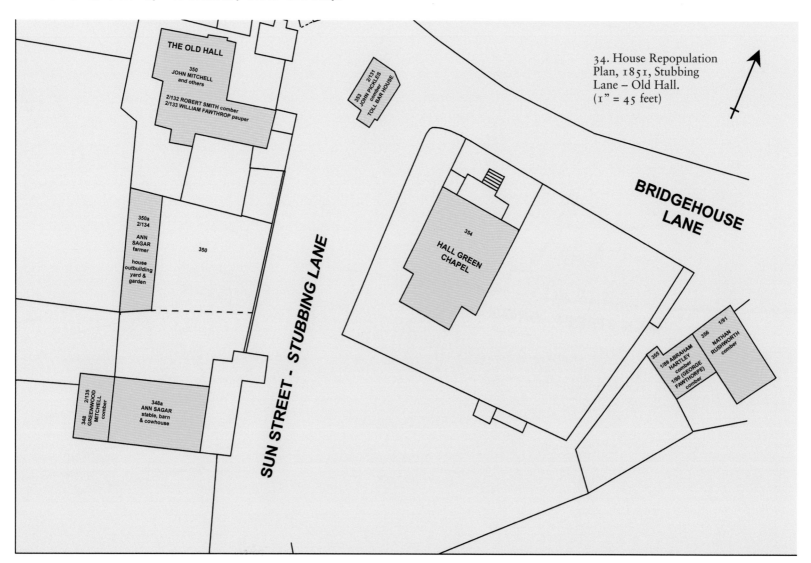

THE OLD HALL

350
JOHN MITCHELL
and others

2/132 ROBERT SMITH comber
2/133 WILLIAM FAWTHROP pauper

353 2/131
JOHN PICKLES
comber
TOLL BAR HOUSE

350a
2/134

ANN
SAGAR
farmer

house
outbuilding
yard &
garden

350

SUN STREET - STUBBING LANE

BRIDGEHOUSE LANE

354

HALL GREEN CHAPEL

348 2/135
GREENWOOD
MITCHELL
comber

348a
ANN SAGAR
stable, barn
& cowhouse

355
1/89 ABRAHAM
HARTLEY
comber
1/90 (GEORGE
FAWTHORPE)
comber

356 1/91
NATHAN
RUSHWORTH
comber

34. House Repopulation
Plan, 1851, Stubbing
Lane – Old Hall.
(1" = 45 feet)

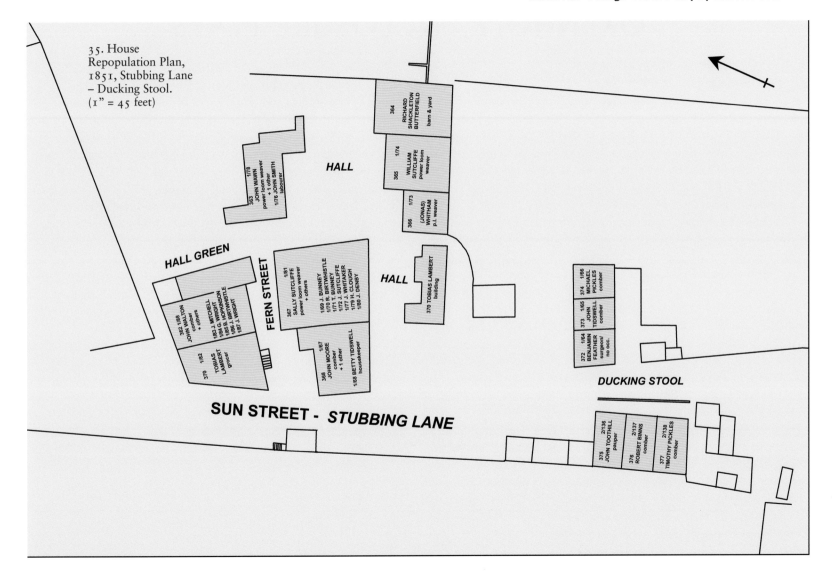

35. House Repopulation Plan, 1851, Stubbing Lane – Ducking Stool. (1" = 45 feet)

HALL GREEN

HALL

HALL

FERN STREET

SUN STREET - STUBBING LANE

DUCKING STOOL

363 1/78 JOHN WAWN power loom weaver + 1 other 1/76 JOHN SMITH labourer

364 RICHARD SHACKLETON BUTTERFIELD barn & yard

365 1/74 WILLIAM SUTCLIFFE power loom weaver

366 1/73 (JONAS) WHITHAM p.l. weaver

362 1/88 JOHN WALTON comber + others 1/83 J.MITCHELL 1/84 G. WRIGHT 1/85 B. HOPKINSON 1/86 J. BIRTWHISTLE 1/87 J. WRIGHT

370 1/82 TOBIAS LAMBERT grocer

367 1/81 SALLY SUTCLIFFE power loom weaver + others 1/69 J. BUNNEY 1/70 R. BIRTWHISTLE 1/71 T. BUNNEY 1/72 J. SUTCLIFFE 1/77 J. WHITAKER 1/79 H. CLOUGH 1/80 J. DENBY

368 1/67 JOHN MOORE comber + 1 other 1/68 BETTY TIDSWELL housekeeper

370 TOBIAS LAMBERT building

372 1/64 BENJAMIN FEATHER surgeon/ no occ.

373 1/65 JOHN TIDSWELL comber

374 1/66 MICHAEL PICKLES comber

375 2/136 JOHN TOOTHILL pauper

376 2/137 ROBERT BINNS comber

377 2/138 TIMOTHY PICKLES comber

OXENHOPE ENCLOSURE MAPS

36. Oxenhope Enclosure, 1660 (1873 copy)

37. Haworth Common, *c.* 1770

38. Oxenhope Enclosure, 1774 (undated nineteenth-century copy)
Enclosure of moorland could be done by individual farmers taking in and improving small parcels of moorland to make new fields, or it could be a more formal, larger scale process. In Haworth and Stanbury the former path was followed and much of the moorland was never enclosed. There are thus few records of the conversion of moorland to pasture and meadow in these two hamlets.

Oxenhope, by contrast, preserves records from two different periods of enclosure – seventeenth-century enclosure by agreement and eighteenth-century parliamentary enclosure. The earlier period is represented by a map (36) showing the enclosure of the Stones area in 1660. The original map does not survive, but there is a copy of it in a nineteenth-century will and a redrawn copy of this is reproduced here. The fact that there is a map and that the land is said to have been awarded on 14 June 1660 shows that this was the more formal type of early enclosure by agreement. The enclosed fields – shaded in red – lie on either side of the Lees and Hebden Bridge turnpike road, which was built in 1813. The area enclosed was about 110 acres, and by the time of the tithe award it was in the hands of a dozen different owners.

In 1771, an act was passed that provided for the enclosure of about 2,000 acres of commons and wastes in the Manor of Oxenhope. The area affected by the act stretched in a great 'U', which starts at Upper Marsh, follows the Haworth boundary to Oxenhope Stoop and then runs south and east along the watershed to Thornton Moor. There is then a gap around Sawood where the land must already have been enclosed. The eastern arm of the 'U' runs along Black Moor and Brow Moor.

There are extensive records of this proposed enclosure, principally the act itself, accompanying maps and lists of land awarded. The map presented here (38) is an extract showing most of the planned enclosure around the head of the Oxenhope valley. It is taken from a nineteenth-century copy of the original 1774 enclosure map.

It is obvious in the landscape that the higher moors did not get improved, although there is a very interesting relic of an attempt to do so at Bentley Allotment on Oxenhope Moor. Here a series of drainage ditches carves about 100 acres of the moor into two dozen rectangular plots. The effects of enclosure on the lower lying land are very obvious. This is dramatically illustrated in the inset photograph on the map, which shows the Haworth–Oxenhope boundary with the unimproved moorland of Haworth to the left and the enclosed fields of Oxenhope to the right. This is the area that is seen along the top edge of map 38, starting around the large cross above Dame E. Assheton's name and running east to the road and beyond.

This boundary is also shown on the map of Haworth Common (37). This redrawn map shows a disputed area of moor claimed by both Oxenhope and Haworth. It must have been necessary to resolve the dispute before Oxenhope could apply for its enclosure act. They must have been keen to secure their act as they ceded all the disputed land to the Manor of Haworth. Reg Hindley has made a study of the Oxenhope enclosures and more information will be found in his 2004 book *Oxenhope: The Making of a Pennine Community*.

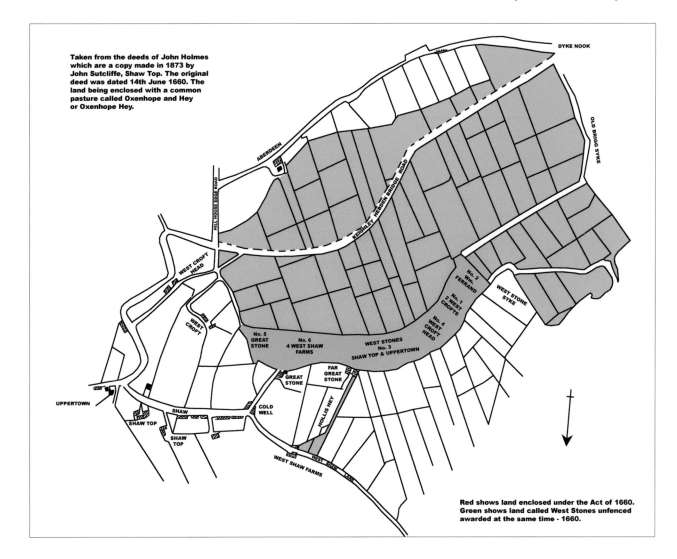

Taken from the deeds of John Holmes which are a copy made in 1873 by John Sutcliffe, Shaw Top. The original deed was dated 14th June 1660. The land being enclosed with a common pasture called Oxenhope and Hey or Oxenhope Hey.

DYKE NOOK

OLD BRIGG SYKE

ABERDEEN

KEIGHLEY HEBDEN BRIDGE ROAD

HILL HOUSE EDGE ROAD

WEST CROFT HEAD

WEST CROFT

No. 2 Wm. FERRAND

No. 1 2 WEST CROFTS

No. 4 WEST CROFT HEAD

WEST STONE SYKE

No. 5 GREAT STONE

No. 6 4 WEST SHAW FARMS

WEST STONES No. 3 SHAW TOP & UPPERTOWN

GREAT STONE

FAR GREAT STONE

UPPERTOWN

SHAW

COLD WELL

HOLLIS HEY

SHAW TOP

SHAW TOP

WEST SHAW FARMS

WEST SHAW LANE

36. Oxenhope Enclosure, 1660 (1873 copy). (x0.4; 7" = 1 mile)

Red shows land enclosed under the Act of 1660. Green shows land called West Stones unfenced awarded at the same time - 1660.

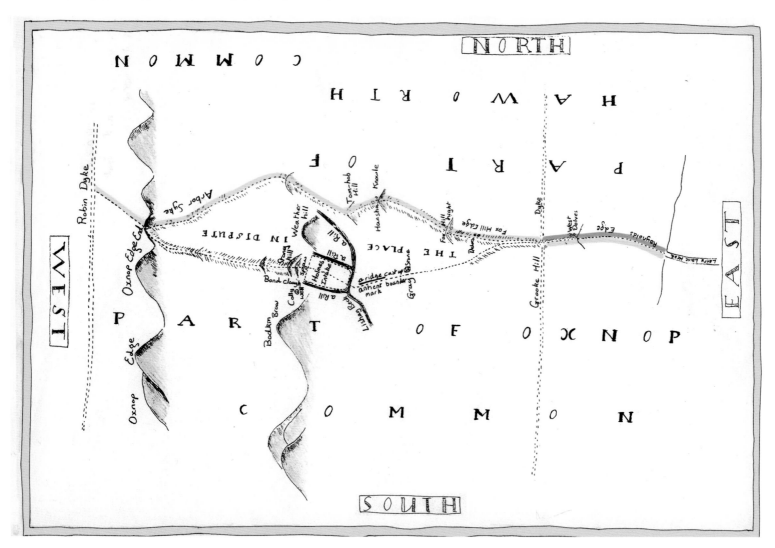

37. Haworth Common, *c.* 1770. (x0.3; 3" = 1 mile)

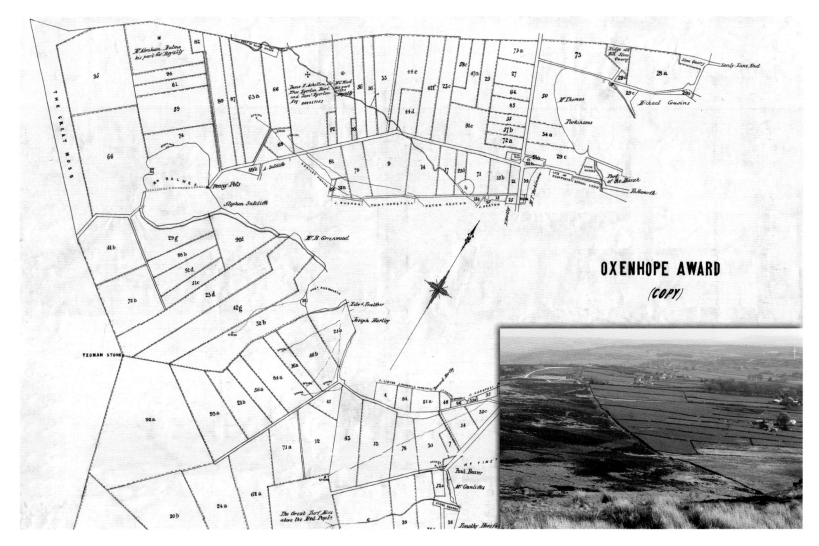

38. Oxenhope Enclosure, 1774 (undated nineteenth-century copy). (x0.3; 3" = 1 mile)

ESTATE MAPS & SALE PLANS

This section comprises examples of a large and varied class of map, which is very useful to the local historian.

39. Emmott, 1769 map
40. Emmott, 1769 terrier
This (39), our earliest detailed map of Haworth village, comes from 'A Survey with Maps of Lands Lying within the Counties of York and Lancaster. Belonging to Richard Emmott Esqr. by R. Lang and T. Addison 1769.' It is accompanied by a terrier giving details of the properties and their tenants, of which the first page is reproduced here (40). Each field bears a number that will also be found in the terrier – 1 for the Cross Inn, 2 for Townend Farm etc. The fields are also coloured with watercolour wash. The significance of these colours is not obvious – they do not relate to tenancies or land use. Buildings belonging to Emmott and the church are depicted as small drawings; other buildings are shown in plan view only.

41. Emmott, 1903
This is an extract from a much later Emmott estate plan: 'W. E. J. Green-Emmott Esq., Haworth Building Estate.' The plan was produced by Barber Hopkinson & Co. in 1903. Those properties that have been sold by the estate are outlined in red. The name of the purchaser, the area in square yards, and, sometimes, the date of sale are noted.

42. Coney Garth, c. 1800
This plan of the Near and Far Coney Garth farms must have been drawn around 1800. It is oriented with north towards the bottom. The road running across the bottom of the plan labelled Hobb Lane is the Blue Bell turnpike road. Where it crosses Ponden Beck there is a depiction of 'Heaton Mill'. There were two water-powered mills close to this point: Ponden Mill, which was a spinning mill, and a corn mill. It is not clear which is meant here. In either case the mill is properly shown on the Oakworth side of the stream but wrongly shown on the north side of the road. The depictions of the farms, their barns and the mill are very attractive and are shown at full size in the insets.

43. Forks House and South Dean, 1817
This map is redrawn from a very faint photocopy at Keighley Library. South Dean and Forks House are the two farms surveyed; the less well-known Keelam and Newton are shown at the top of the map. All four are now in ruins. The fields are labelled with their state of cultivation (meadow or pasture) and their area expressed as 'days work'. The 'day work' – the amount of land that could be mown in a day – was about two thirds of an acre.

The buildings are shown in some detail with the barn and house labelled. At the eastern end of the map a coal mine and its drainage ditch are shown – both are still clearly visible. At the western end is Forks House Mill with its mill dam labelled 'W'. The three 'low rooms for cottages' presumably housed the spinners who worked there.

44. Hollins Mill, 1832
The Blue Bell turnpike road runs along the bottom edge of this lovely map. From left to right the buildings are Milking Hill, Sladen Bridge cottages, Hollins, Hollins Mill, Rough Nook and Oldfield Gate. The numbers refer to a terrier, which is not shown here. The owner was Jn Cousen. The mill was tenanted by Thomas Lister, after whom it is still locally called Lister's Mill. The goit that feeds the mill dam starts near Sladen Bridge but is covered for most of its length.

45. Haworth, James Greenwood, 1848
46. Haworth, James Greenwood, 1848 detail

The Greenwoods were a prominent mill-owning family in Haworth for a century and a half. They originally came from Calderdale in the 1690s and by the later eighteenth century had established a textile mill at Bridge House. If the Greenwoods made working surveys of their Haworth estates they do not survive, but we do have this very fine plan of the Bridge House estate of James Greenwood. It was produced when the estate was sold following Greenwood's 1848 bankruptcy. First (45) is a much reduced copy of the whole plan and second (46) a larger scale detail showing Greenwood's 1832 house Woodlands, the Georgian dwelling at Bridge House and the Bridge House mill complex. The latter two are shown in more detail in the inset. This survey captures the old Upper Mill and Lower Mill at Bridge House, which were to be replaced by a new mill just a few years later. The mill goit shown here dates from 1813 and still survives, although the rather puzzling reservoir between the goit and the beck has long since vanished.

47. Spring Head, Joseph Greenwood, 1853

Five years after James Greenwood's bankruptcy his brother Joseph's business also failed. This unfortunate occurrence produced a splendid set of plans of his properties in Oxenhope, Haworth village and at Spring Head. The detail included here shows Joseph Greenwood's house at Spring Head and his nearby mill. Two mill dams are shown; the smaller one is fed by a covered goit from the River Worth (see 48) and clearly supplies a waterwheel inside the mill. We know less of the larger reservoir; it is not clear where it got its water nor is its purpose known. Presumably it served as an extra water supply to Spring Head Mill but it might just have been part of the water supply to Mytholmes Mill further downstream. Whatever it was for, it had gone by 1892, when a large new mill building occupied its site. Between it and the river is a gas holder.

Many mills made their own gas, which they used principally for lighting to extend the working day in winter.

48. Spring Head water supply, 1902

The water supply system of Spring Head mill is shown on this 1902 map. Water is taken from the weir at Seville Holme to the mill dam in a covered goit. A short tail goit runs from the east end of mill buildings to a weir at which the Mytholmes Mill goit starts. The latter is open for a short distance before entering a tunnel. The stretch of the Worth in Seville Holme is locally called /ðə klɑː/ – a name that has long been a puzzle. The weir on Seville Holme used to be called the Higher Clough and the sluices at the Mytholmes Mill weir are called 'clows' in a document of 1825. 'Clough', and 'claa' are local variants of 'clow' – a sluice. Thus we now have an explanation of, and a spelling for, The Claa.

49. Haworth, Joseph Greenwood, 1853

This sale plan of Joseph Greenwood's Haworth village properties provides us with a large-scale plan of the top of Haworth forty years before the first 25 inch OS plan. The sale particulars (not included here) show that he owned five cottages and a bakery in Church Street, four cottages near the Head Well – the main water supply for this part of Haworth – and the Sun Inn on West Lane. As well as being an inn, the Sun had a butcher's shop and a piggery. The long strip of land labelled Townfield Allotment is described in the sale particulars as a Dole (i.e. a share) of Land in the Townfield. It is a relic of the medieval open fields.

50. Oxenhope Mill, G. D. Greenwood, 1884

In 1884, George Dean Greenwood, a distant relation of James and Joseph Greenwood, put his Oxenhope properties up for sale. Among them was Oxenhope Mill, which was then a textile mill but was on the site of the

medieval manorial corn mill. The water supply of the mill is well displayed on this plan. A goit leads from a weir on Leeming Water through Stack Holme to the reservoir. This stores water to supply the waterwheel inside the mill. Water is returned to Bridgehouse Beck by the tail goit. The supply was supplemented in an unusual manner by water taken from Moor House Beck, near Fisher's Lodge (not on this plan), and carried in a goit that crosses the Long Close fields and enters Leeming Water just above the weir. Reference to (86) should make these arrangements clearer. The circle labelled 'Omiter' (for 'gasometer') is a gas holder.

51. Old Oxenhope Mill and Grammar School, G. D. Greenwood, 1884

Old Oxenhope Mill did not belong to G. D. Greenwood (it was then owned by another relative, John Broadley Greenwood) but is well displayed on this plan, as is the old grammar school.

The main millpond is on the top side of Hanging Gate Lane. The smaller pond shown here is a puzzle – it is immediately in front of the house and is not shown on OS plans of the period. Above the house is the mill and above that a row of workers' cottages. The inset is a portrait of Barber Hopkinson, the Keighley surveyor who made this plan and many others in this book.

52. Vale Mill Estate, R. N. Sugden, 1884

In the left centre of this extract is the wooden trestle bridge that carried the Worth Valley branch line over the Vale Mill dam. Only the part of the plan between the River Worth and Bridgehouse Beck is in Haworth township – most of the upper part is in Cross Roads. Along the bottom of the plan are Mytholmes Mill and workers' houses at Spring Row, Office Row and Mytholmes Terrace. The covered tail goit of Mytholmes Mill is clearly shown just left of the Worth. Lower Mytholmes farm was to disappear soon after this plan was drawn – it was demolished when the trestle bridge was replaced by Mytholmes tunnel.

53. Stanbury and Griff Mill, 1891

Griff Mill itself was not part of this sale of George Firth's properties but it was for sale at the same time. Griff's owners, Williamson Brothers, had gone bankrupt in 1884 and the mill was not occupied again until Townend Brothers leased it in 1895. Griff was built in the valley bottom between Stanbury and Oldfield in the 1790s in order to use the River Worth as its power source. This valley bottom site proved a hindrance in later years as access was difficult from either side of the valley. The Griff Mill Road shown on this plan is now almost impassable on foot in places. Remarkably it was used by cars within living memory.

54. Brooks Meeting Mill, 1879

Brooks Meeting Mill occupied another valley bottom site between Shaw and Moorside in Oxenhope. This sale plan shows the complex arrangement by which it drew water from both of the streams from whose confluence it takes its name. There are an overflow sill and two sluice gates to return surplus water to the beck before a final sluice delivers water to the wheel pit. The enlarged inset displays the unusually full labelling of the mill building in which the wheel pit is clearly identified – although the course of the tail goit is not shown.

55. Rush Isles, 1799

This plan of Rush Isles was made to record William Heaton's purchase of a spring from Jonathan Walton. The line A–B shows the drain by which water from the spring at A was taken to Rush Isles, presumably to a trough in the farm yard. William Heaton kept a remarkable book of recipes for the ailments of man and beast. These feature some odd ingredients, whick worms, toad slubber and black snails among them. The relatively innocuous recipe for an ointment shown in the inset is signed by him and dated 8 May 1808.

56. Old Snap Farm, 1828

Here is one page from a small book of plans of 'estates formerly belonging to Mr. Chr[istophe]r Moorhouse' drawn by J. B. Ingle in 1828. The reference table for this 55 acre farm gives the field names and acreages in A. R. P. – acres, roods and perches. The Blue Bell turnpike road is drawn in at the top of the plan and the boundary with the Heatons' Ponden estate on the right. The small, isolated mound at Silver Hill has occasioned much (no doubt unfounded) speculation about buried treasure.

57. Woodcock Hall Quarries, c. 1871

For some reason quarry owners tend to leave very little documentary record of their work. No doubt this is one reason why this important and fascinating industry has received relatively little attention from local historians. This little plan of two quarries by the Oxenhope–Warley boundary near Fly Flat Reservoir is a rare survivor. The top quarry is shown as disused. The lower quarry is the one being worked and shows the quarry track, spoil heaps, quarry buildings, two areas worked in 1854 and the large area of stone 'ungotten'. The Woodcock Hall quarries were finally closed in 2007.

58. Rag Clough, 1872

Rag farm lies in ruins a few hundred yards off the Cock Hill Road above Oxenhope. Three aqueducts are marked in red on this plan. From left to right they are the conduits taking water to the Thornton Moor, Stubden and Leeshaw reservoirs. The farm's water supply is also clearly shown on this plan. A watercourse conveys water from Rag Spring on the moor to a well near the farm. The quarries near Rag Clough Beck were worked for a very rough millstone grit used for making millstones or pulping stones – hence the name Grinding Stone Hole, which appears on the 6 inch OS map.

59. Black Bull and Cross Inn, 1898

This very large-scale plan of the top of Haworth Main Street is particularly useful for its detailed plans of the layout of two of the village's inns. On the left is the famous Black Bull, which has associations ranging from William Grimshaw (who disapproved), through Branwell Brontë (who approved only too well) to Max Beerbohm (who had lunch there with Thomas Hardy's widow). On the right is the now forgotten Cross Inn, which has been converted into a number of shops and dwellings. Part of it has very recently become licensed premises again. Notice that each of the inns had stables for visitors' horses and the Bull had a barn and mistals – it was a farm as well as an hotel.

60. Stanbury Moor, 1902

There had been a long-running dispute about the allocation of shooting rights over Stanbury Moor, which featured a man called Pepper. He seems to have been building up an extensive shooting estate and causing friction in a number of places. The upshot in Stanbury was that a Chancery Division judge became involved and ordered the moor to be sold. Keighley Corporation was quick to seize this opportunity to buy 1,000 acres of the gathering grounds for its reservoirs. It cost them just £9,000. Walkers on some of the more remote parts of the moor will still encounter boundary stones inscribed 'KC 1902', which Keighley Corporation erected to mark its newly acquired property.

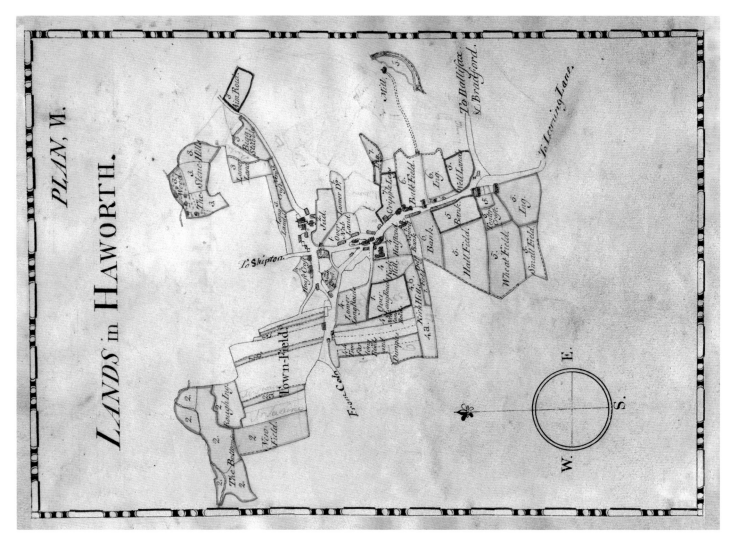

39. Emmott Estate Plan, Haworth, 1769. (x0.8; 7" = 1 mile)

LANDS in HAWORTH.

(11.)

N°	PREMISES	Quantity of Land I:e measure A.R.P.	Quantity of Land Pest: Land: A.R.P.	Quantity of Value £	Yearly Value L.s.D.
1.	**James Wood and William Hopkinson** } Farm.				
Plan M.	The Cross Inn 2 Bays and a Cellar thereon One other House 2 Bays with a Stablenne			9	18 -
	Bay at the North end thereof a Barn 2 Bay in Cottage one Bay all None and Naled	25	-	65	2 16 10
	with the Backside	3 24	3 20	65	2 16 10
	Over Nab Lands	2 -	1 36	65	1 10 11
	Lower Nab Land	1 28	1 25	50	- 19 1
	Scivell Bank	2 34	2 28	45	3 15 6
	The over Long Field	2 -	2 -	38	1 14 3
	In the Town Field	1 20	1 20	39	- 19 -
	Deep Field	1 34	1 27	-	1 -
	} b. } c.				
	Survey	5 - 05	4 2 36	21	21
2.	**George Sharp.**				
Plan M.	House 5 Bays Barn 4 Cottages one in the End	1 34	1 24	-	4 7 7
	The Barn Garden and House Croft	1 10	1 8	60	18 -
	Sock Croft	- 14	- 13	60	5 3
	Little Croft	1 22	1 16	65	3 11 6
	Tudd	- -	2 23	38	1 4 5
	In the Town Field } a.	2 26	2 2	40	1 3
	New Field	2 13	1 5	25	1 12 -
	Rough Ing	1 12	- 15	3	1 -
	Bottoms &c.	4 21	1 4		
	Survey	10 3 32	10 1 14	20	20

40. Emmott Estate Plan, Haworth Reference, 1769.

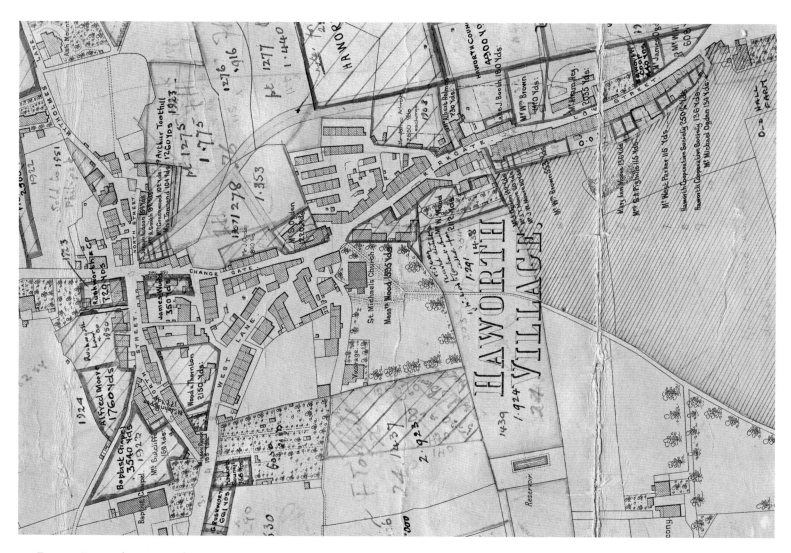

41. Emmott Estate Plan, Haworth, 1903. (x0.9; 23" = 1 mile)

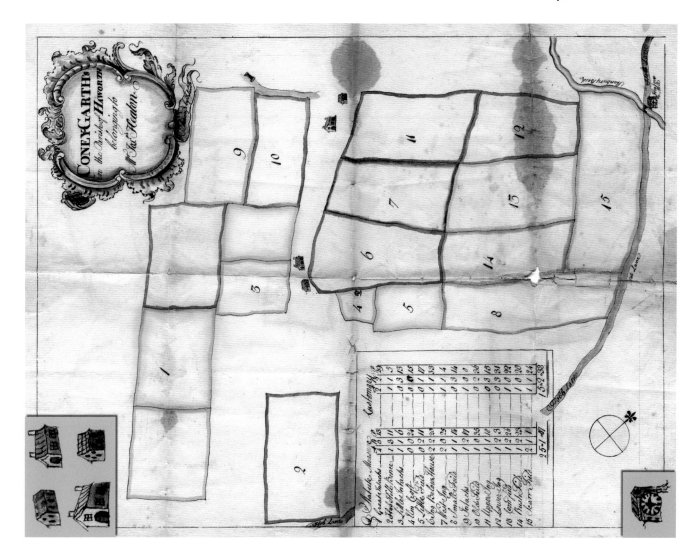

42. Coney Garth,
c. 1800. (x0.4;
21" = 1 mile)

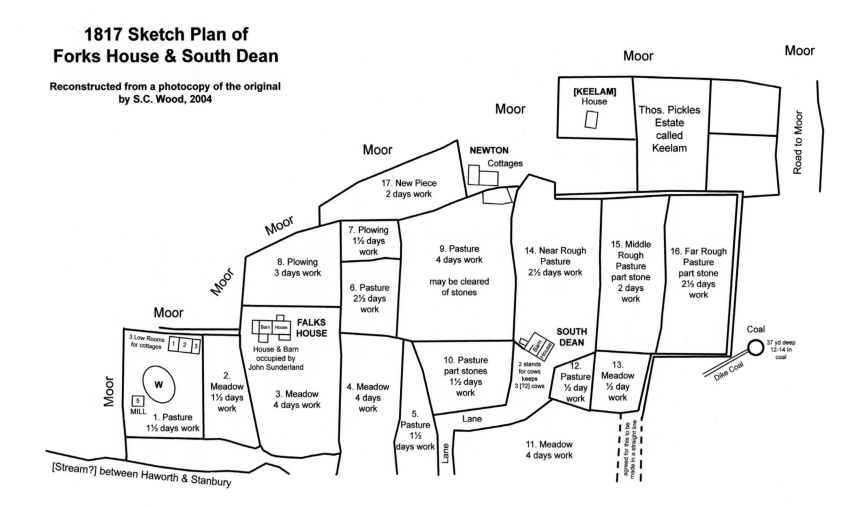

1817 Sketch Plan of Forks House & South Dean

Reconstructed from a photocopy of the original
by S.C. Wood, 2004

Moor

Moor

Moor

Moor

[KEELAM] House

Thos. Pickles Estate called Keelam

Road to Moor

Moor

NEWTON
Cottages

17. New Piece
2 days work

7. Plowing
1½ days work

9. Pasture
4 days work

may be cleared
of stones

14. Near Rough
Pasture
2½ days work

15. Middle
Rough
Pasture
part stone
2 days
work

16. Far Rough
Pasture
part stone
2½ days
work

Moor

8. Plowing
3 days work

6. Pasture
2½ days
work

Moor

Moor

3 Low Rooms
for cottages

1 2 3

Barn House

FALKS
HOUSE

House & Barn
occupied by
John Sunderland

SOUTH
DEAN

Barn
House

Coal

37 yd deep
12-14 In
coal

2.
Meadow
1½ days
work

3. Meadow
4 days
work

4. Meadow
4 days
work

10. Pasture
part stones
1½ days
work

2 stands
for cows
keeps
3 [?2] cows

12.
Pasture
½ day
work

13.
Meadow
½ day
work

Dike Coal

Moor

W

5
MILL

1. Pasture
1½ days work

5.
Pasture
1½
days work

Lane

Lane

11. Meadow
4 days work

agreed for this to be
made in a straight line

[Stream?] between Haworth & Stanbury

43. Forks House and South Dean, 1817. (x0.6; 15" = 1 mile)

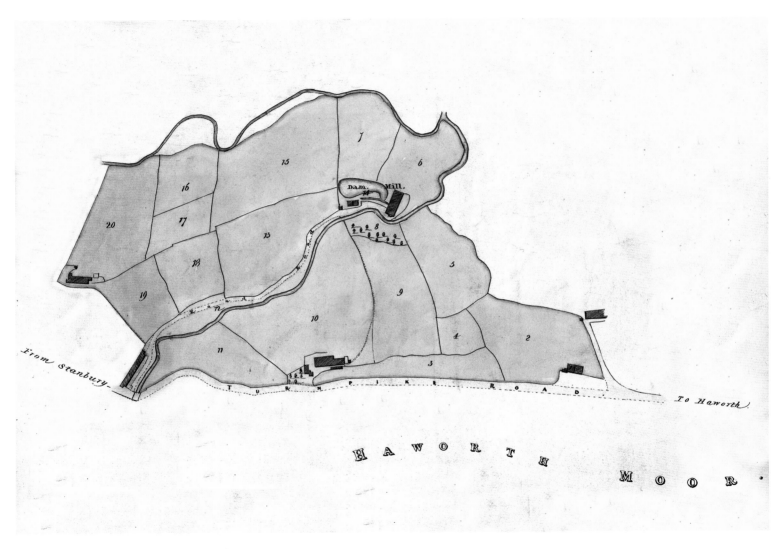

44. Hollins Mill, 1832. (x0.6; 16" = 1 mile)

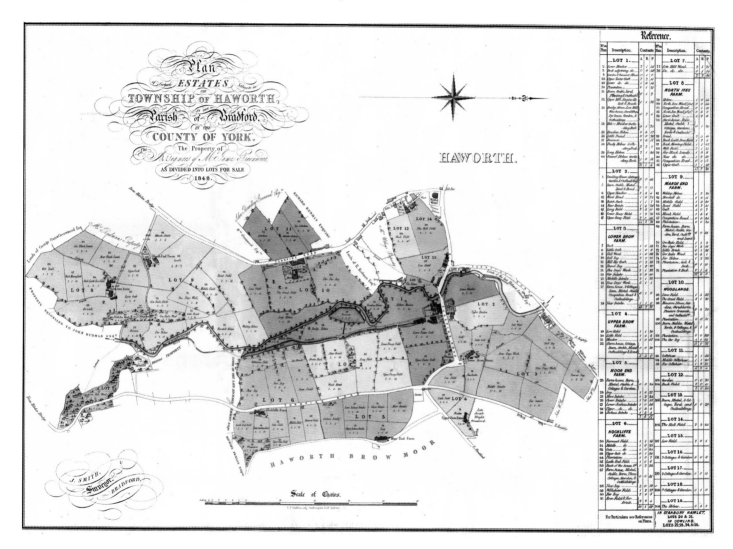

45. Haworth, James Greenwood, 1848. (xo.3; 6" = 1 mile)

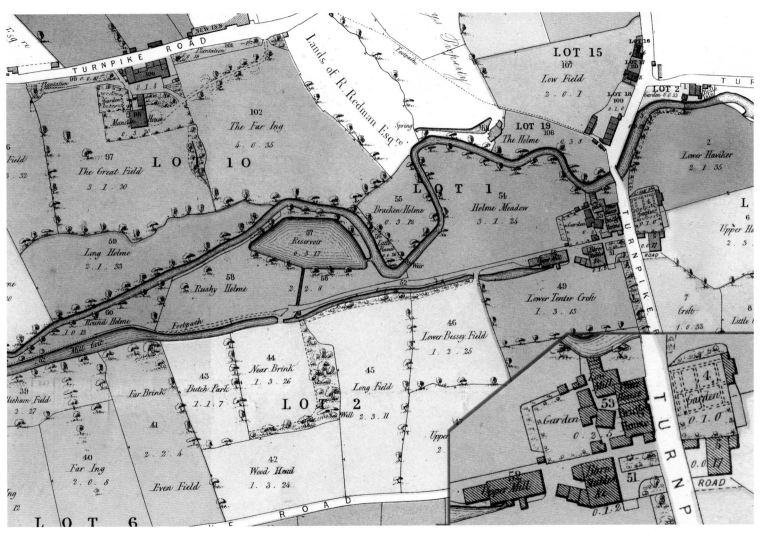

46. Haworth, James Greenwood, 1848 detail. (x1; 20" = 1 mile. Inset x2; 40" = 1 mile)

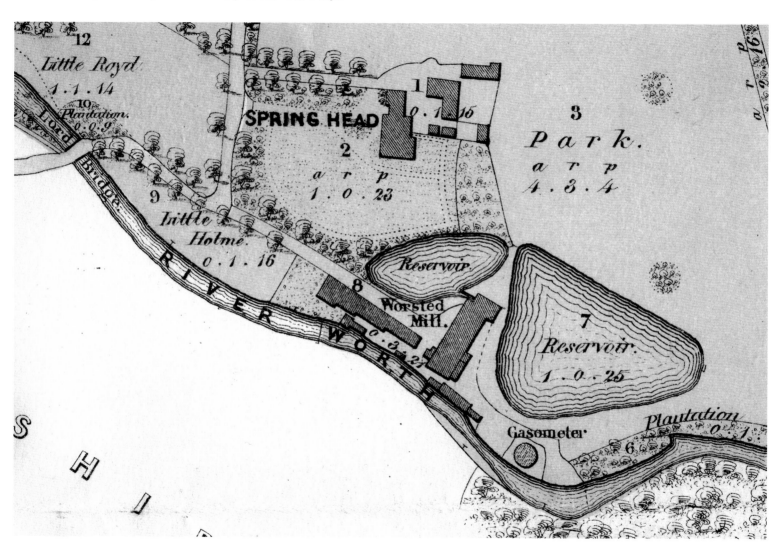

47. Spring Head, Joseph Greenwood, 1853. (XI.8; 47" = 1 mile)

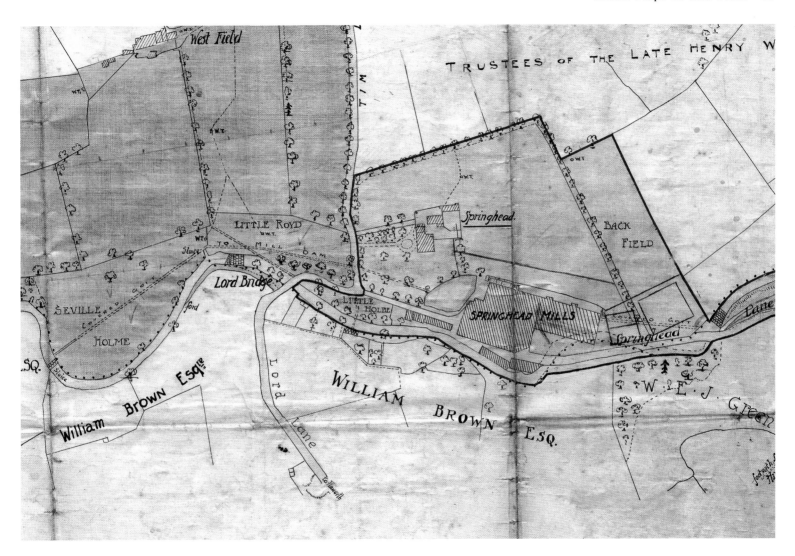

48. Spring Head water supply, 1902. (x0.8; 20" = 1 mile)

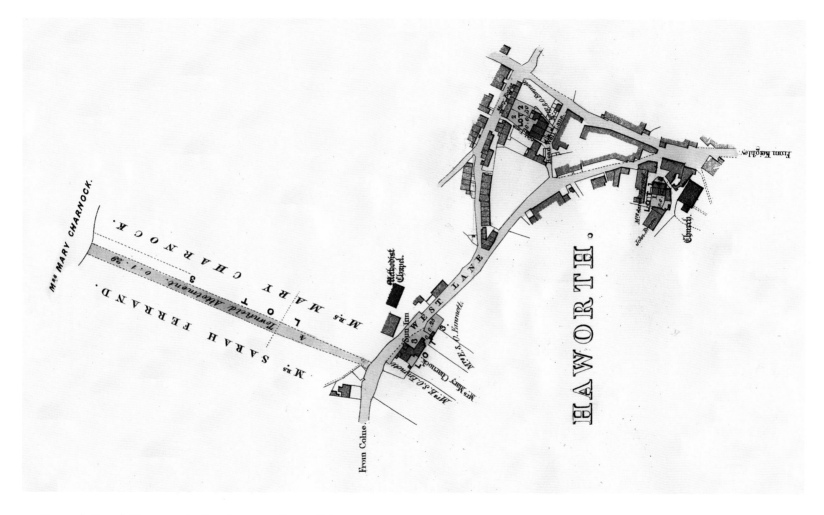

49. Haworth, Joseph Greenwood, 1853. (x0.75; 20" = 1 mile)

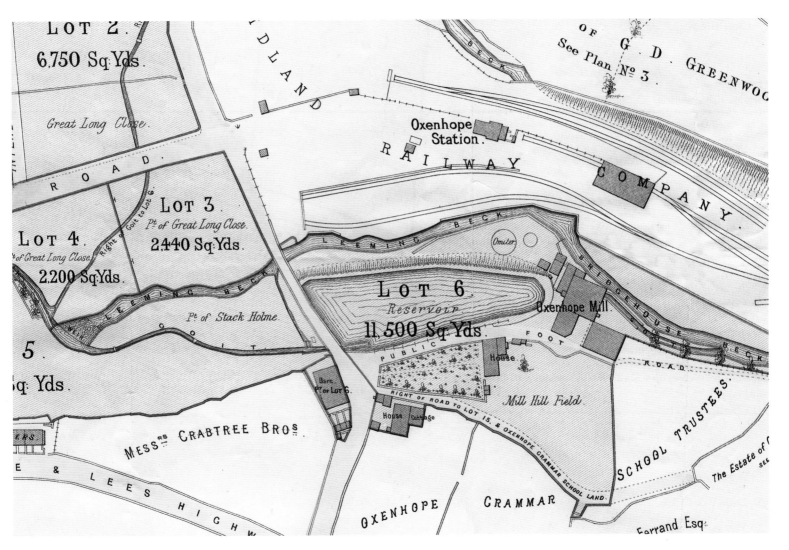

50. Oxenhope Mill, G. D. Greenwood, 1884. (x0.75; 50" = 1 mile)

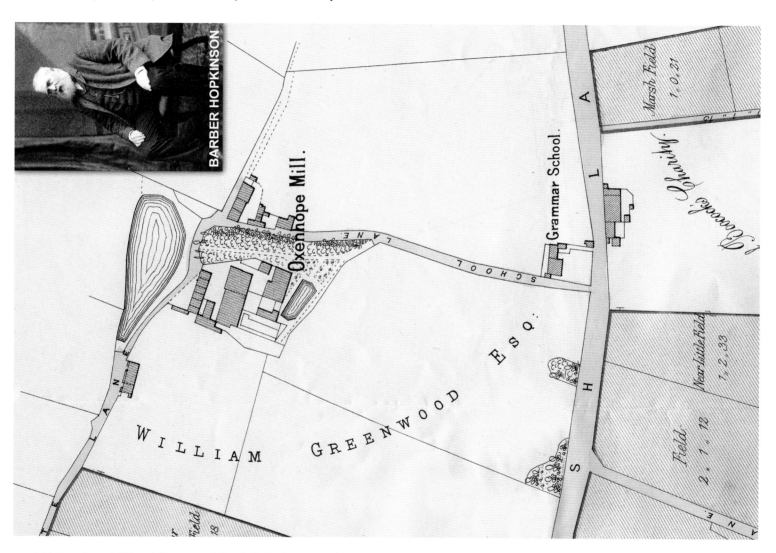

51. Old Oxenhope Mill and Grammar School, G. D. Greenwood, 1884. (XI; 27" = 1 mile)

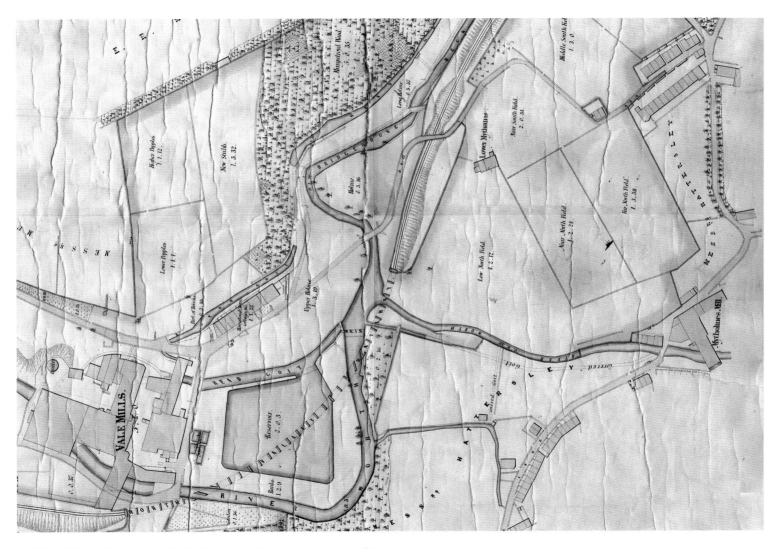

52. Vale Mill and Mytholmes, R. N. Sugden, 1884. (xo.3; 22" = 1 mile)

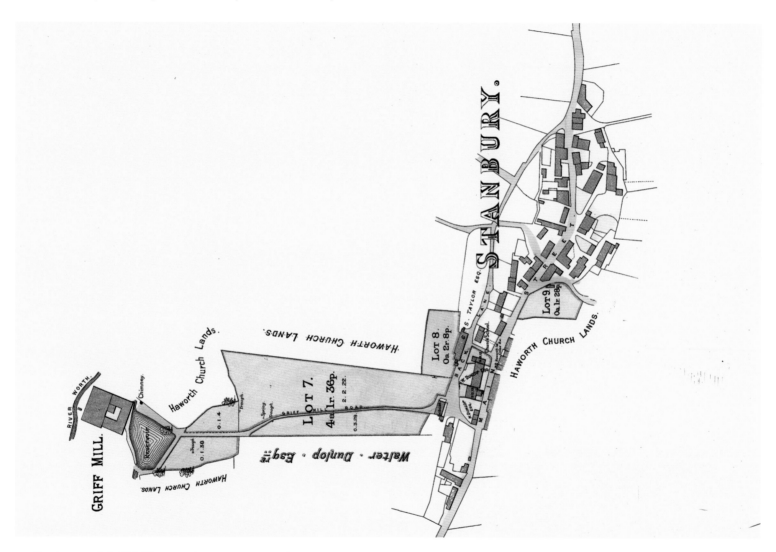

53. Stanbury and Griff Mill, 1891. (x0.65; 17" = 1 mile)

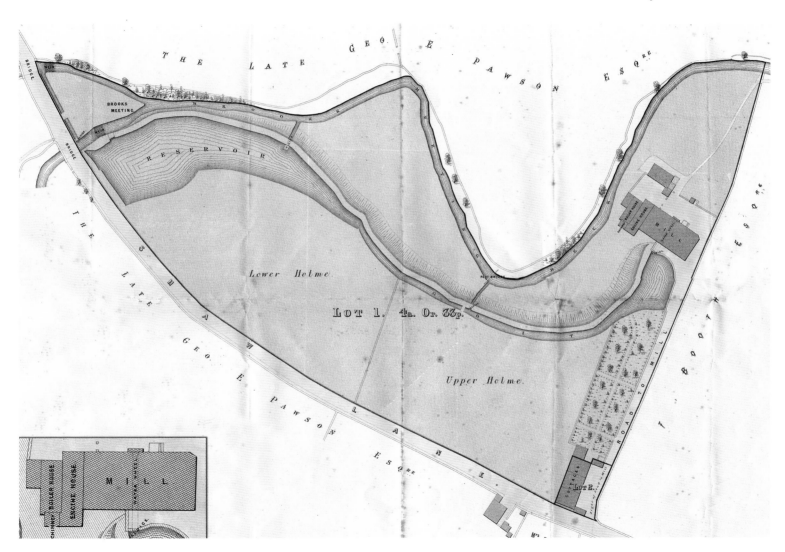

54. Brooks Meeting Mill, 1879. (x0.33; 53" = 1 mile. Inset x0.66; 106" = 1 mile)

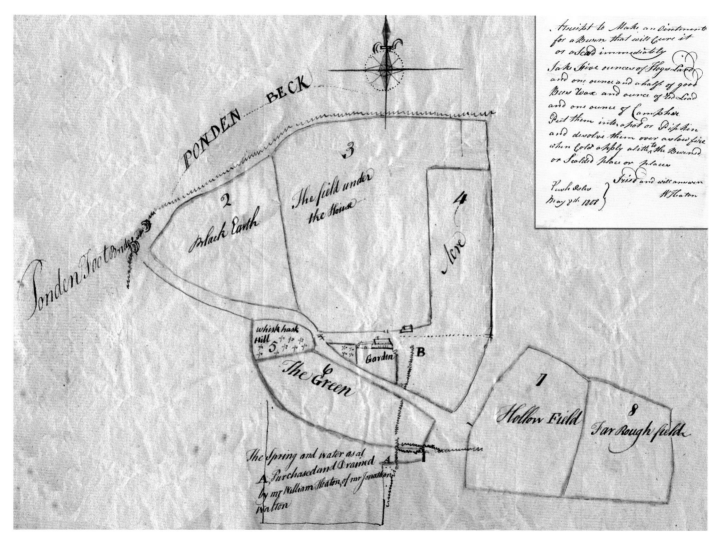

55. Rush Isles, 1799. (xo.7; 24" = 1 mile)

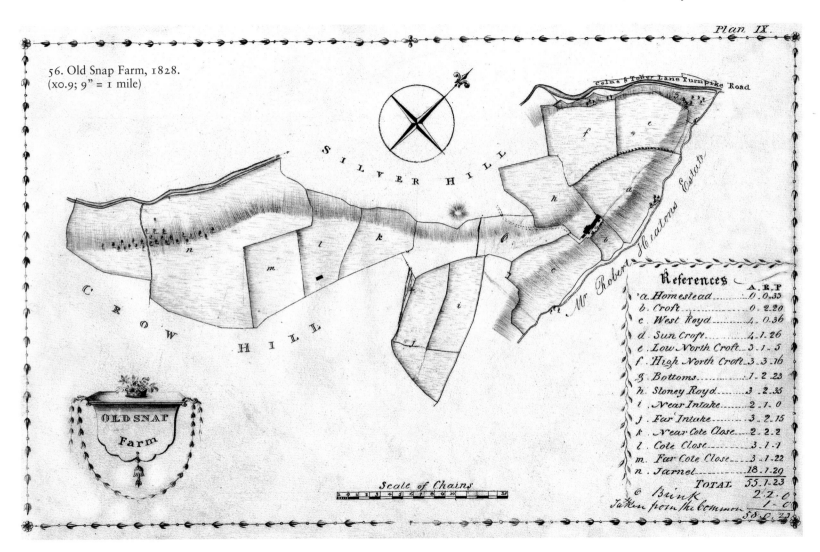

Plan IX.

56. Old Snap Farm, 1828.
(x0.9; 9" = 1 mile)

SILVER HILL

CROW HILL

OLD SNAP
Farm

Colne & Tatter Lane Turnpike Road

Mr Robert Heatons Estate

Scale of Chains

References

		A. R. P
a	Homestead	0 . 0 . 33
b	Croft	0 . 2 . 20
c	West Royd	4 . 0 . 36
d	Sun Croft	4 . 1 . 26
e	Low North Croft	3 . 1 . 5
f	High North Croft	3 . 3 . 16
g	Bottoms	1 . 2 . 23
h	Stoney Royd	3 . 2 . 35
i	Near Intake	2 . 1 . 0
j	Far Intake	3 . 2 . 15
k	Near Cote Close	2 . 2 . 2
l	Cote Close	3 . 1 . 1
m	Far Cote Close	3 . 1 . 22
n	Jarnel	18 . 1 . 29
	TOTAL	55 . 1 . 23
o	Brink	2 . 2 . 0
	Taken from the common	1 . 0 . 0
		58 . 0 . 23

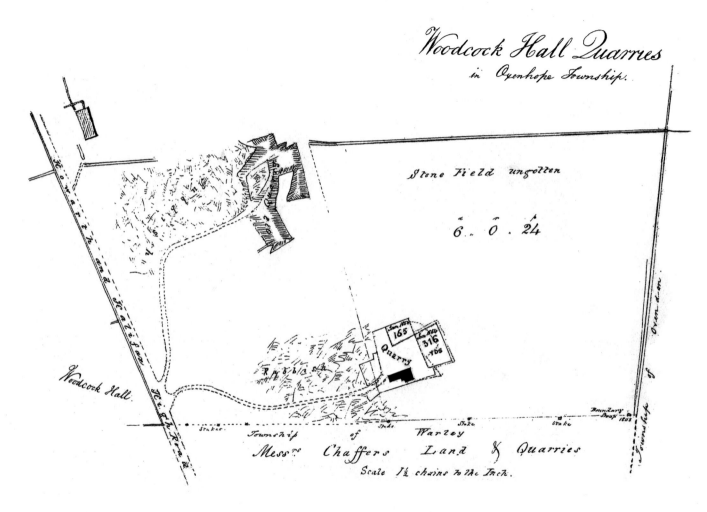

57. Woodcock
Hall Quarries,
c. 1871.
(x0.6; 32" =
1 mile)

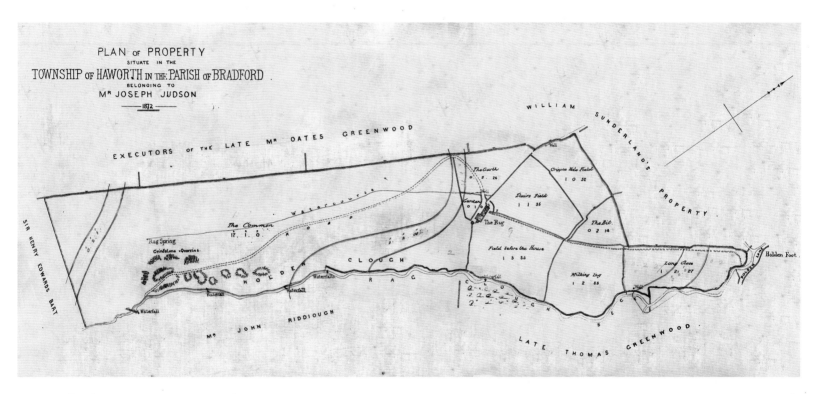

58. Rag Clough, 1872. (x0.35; 14" = 1 mile)

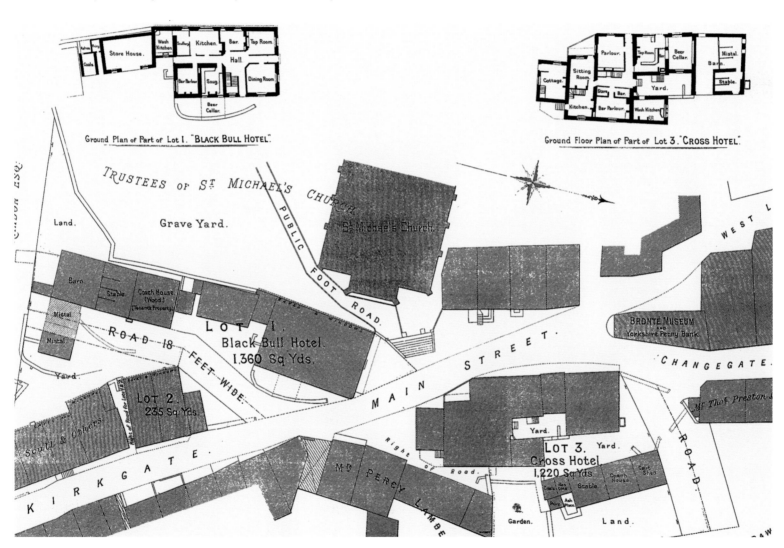

59. Black Bull and Cross Inn, 1898. (x0.4; 1" = 50 feet)

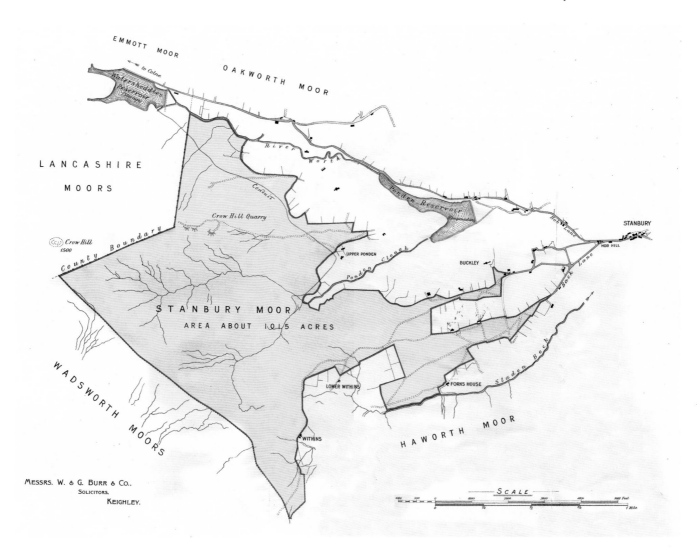

EMMOTT MOOR

OAKWORTH MOOR

to Colne

Watershedalts Reservoir Sewage

LANCASHIRE

MOORS

River Worth

Ponden Reservoir

Conduit

Crow Hill Quarry

Crow Hill 1500

County Boundary

Upper Ponden

Ponden Clough

Hob Lane

STANBURY

HOB HILL

BUCKLEY

Back Lane

STANBURY MOOR

AREA ABOUT 1015 ACRES

Sladen Beck

WADSWORTH

MOORS

LOWER WITHINS

FORKS HOUSE

HAWORTH MOOR

WITHINS

60.
Stanbury
Moor, 1902.
(xo.3;
2" = 1 mile)

MESSRS. W. & G. BURR & CO.,
SOLICITORS,
KEIGHLEY.

SCALE

HAWORTH PARISH CHURCH PLANS

St Michael and All Angels is of ancient foundation. The first reliable mention of it is in 1317 and that implies its existence from 'ancient times'. Stories of an even greater antiquity, with a foundation date of AD 600, probably stem from the misinterpretation of an old inscription relating to the Chantry Chapel, founded in 1338. I suspect that this supposed medieval church was used by Haworth in its disputes with the Vicar of Bradford in the eighteenth century.

61. Church ground floor plan, 1757
62. Church gallery plan, 1768
The church was enlarged and extensively rebuilt in 1755 to accommodate the large congregations attracted by William Grimshaw's preaching. Unfortunately, the plans that accompanied the faculty for this work have not survived. The earliest plans we have are two seating plans: the main body of the church, 1757, and the gallery, 1768.

The 1757 plan of the church (61) shows box pews along the north and south walls and in the centre of the nave. The names of the inhabitants with the number of sittings each held are written in the pews. The baptismal font is located near the south door, with an entrance to the tower beside it. The vestry is shown near the north door. At the east end of the church are the altar rails, within which was a simple communion table (still to be seen in the church today). The main focus of this evangelical church was the triple-decker pulpit in the middle of the south wall. Its three tiers are labelled 'Clerk's Desk', 'Reading Desk' and 'Pulpit'. The latter survives at St Gabriel's in Stanbury. Two pews along from the pulpit is a 'Little Door', which would have been used by the clergy. It was blocked in 1838.

The gallery plan (62) also gives details of holders of sittings but in tabular form. At the back of the west gallery is a bench 'For the Singers'. Perhaps this was for the west gallery band?

63. Church plans (ground floor and gallery), 1863
These two plans by Eli Milnes were most probably drawn in connection with proposed alterations to the church in 1863. Although the plans were not carried out, very similar changes were made in the early 1870s. These plans give a good idea of the layout of the church between 1872 and its demolition in 1879. The whereabouts of the original plans is unknown – these copies were prepared from photocopies found at the Rectory. Note that the copies used were incomplete and the tower staircase entrance shown here is my reconstruction.

64. Church faculty plan, 1879
John Wade, who succeeded Patrick Brontë at Haworth, found the old church damp, dark and cramped. With the gift of £5,000 from Michael Merrall, he set about the demolition of Grimshaw's church and the building of the present church. Only the tower survives from the earlier building (it might be as old as 1488). The faculty plan reproduced here is one of the most important documents for the study of the old church, which is shown in grey with the new church in red.

65. Church model, c. 1880
This model of the old church was made out of oak from the pews by J. E. Moorhouse of Skipton. It is the only representation we have of the north elevation of the 1755 building. While it is accurate in most respects, Moorhouse missed two windows on the upper level (see 63 for the evidence). The inset shows the model with these two windows added digitally.

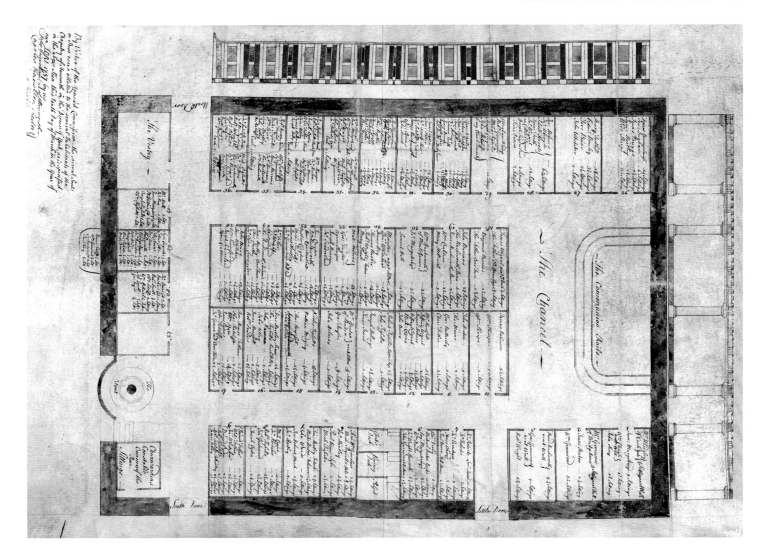

61.
Church
ground
floor
plan,
1757.
(x0.25;
1" =
11 feet)

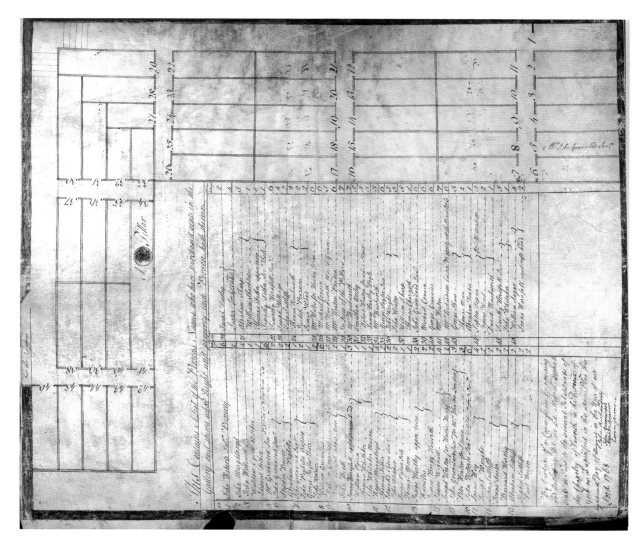

62. Church gallery plan, 1768. (x0.25; 1 = 9 feet)

GROUND FLOOR

GALLERY

63. Church plans (ground floor and gallery), 1863. (n/k; 1" = 16 feet)

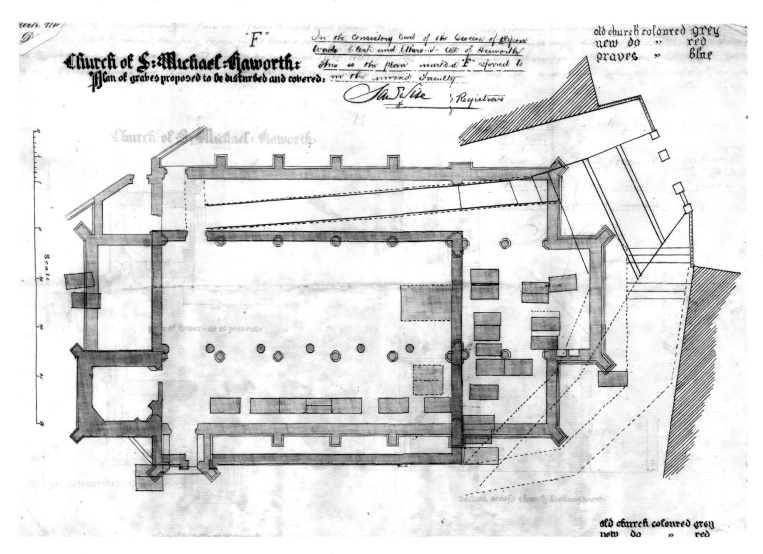

64. Church faculty plan, 1879. (x0.4; 1" = 20 feet)

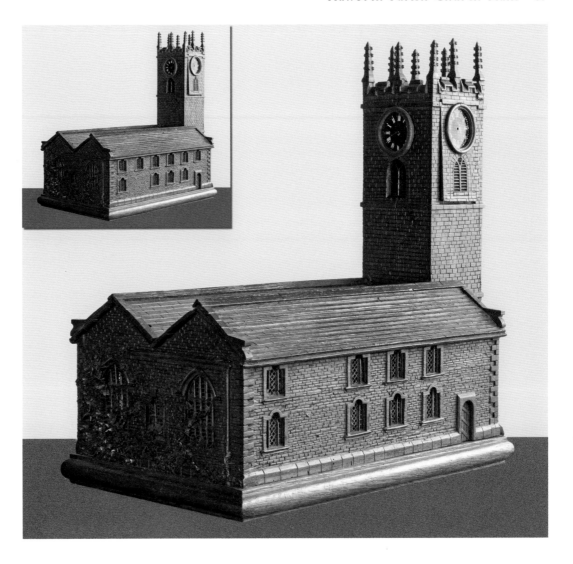

65. Church model, *c.* 1880.

WORTH VALLEY WATERWORKS PLANS

Reservoirs and their catchwater drains are a prominent feature of the upper Worth Valley. As Bradford and Keighley expanded rapidly in the nineteenth century, their need for new sources of water became pressing. Both towns looked to the Worth Valley to supply the water they so urgently needed. At first their ambitions overlapped and clashed, but they quickly agreed to split the valley between them, with Bradford taking water from the Oxenhope valley and Keighley building its reservoirs on the Stanbury branch of the valley.

Obviously it was necessary to produce large-scale plans of the proposed works as a preliminary to construction. Plans also had to be submitted to Parliament to secure the necessary Acts for construction. This means that the waterworks are a rich source of plans for parts of our area.

66. Watersheddles Reservoir, 1868
Keighley originally planned four reservoirs in the Stanbury branch of the Worth Valley: Watersheddles, Ponden, Bully Trees and Lower Laithe. Watersheddles and Ponden were built in the 1870s. Watersheddles Reservoir sits at the very head of the Worth Valley and, owing to an anomaly in the county boundary, is actually in Lancashire. This meant Keighley had to pay rates to the Lancashire authority for its own reservoir. The reservoir needed to be high up so that water could run to the highest parts of Keighley under gravity. This situation meant that the natural gathering ground was small and water had to be brought by two long aqueducts (see 67 for details).

67. Ponden–Watersheddles Aqueduct, 1868
This parliamentary plan shows one of the two aqueducts that bring water to Watersheddles Reservoir. 'Work 15', marked on this map, is the Ponden Aqueduct, which collects water from the head of Ponden Clough. As the map shows this water is carried north-east to Upper Ponden, where it swings round and runs north-west to the reservoir. The Limits of Deviation are very obvious here – these show the extent to which the work can deviate from the planned line without requiring amendment of the Act. 'Work 4' is the line of pipes to Keighley – the other aqueduct is to the north of this and is not on this map.

68. Ponden Reservoir, 1868
The construction of Watersheddles Reservoir and its aqueducts diverted a large volume of water out of the upper Worth Valley to supply Keighley. This meant that there would have been a diminished flow in the Worth, which would have reduced the water power available to mills downstream. Ponden Reservoir was built as a compensation reservoir to ensure an adequate supply of water to the mill owners. Ponden Water was the millpond for Ponden Mill; it was submerged in the new reservoir along with the old road to Ponden Hall.

69. Moorhouse Reservoir (proposed), 1868
Keighley originally proposed to build two reservoirs in the Oxenhope branch of the Worth Valley: Bodkin Bridge and Moorhouse. Bodkin Bridge was to have supplied Keighley, while Moorhouse would have been a compensation reservoir for the mills. Moorhouse Reservoir would itself have submerged two mills: Brooks Meeting and Fisher's Lodge. The water supply systems of these two mills are well seen in this plan. The two millponds at Fisher's Lodge were locally called the apple and pear dams from their shapes. The more westerly pear dam is rather puzzling. Its only obvious outlet is to the stream and it can hardly have supplied Fisher's Lodge Mill. Presumably it served to store water

for Oxenhope Mill. Neither Moorhouse Reservoir nor Bodkin Bridge Reservoir was built, but Bradford's Leeshaw Reservoir is in much the same position as Bodkin Bridge would have been.

70. Oakworth–Haworth Aqueduct, 1868

Although Haworth had its own small reservoirs (Church Hills and Hough), there was from the start provision for Keighley to supply Haworth with water when needed. Water from Watersheddles Reservoir was treated at works above Oldfield then carried to the service reservoir at Black Hill. A proportion of this water was (and still is) diverted to Haworth by a pipeline crossing the valley at Lord Bridge. The Flat Lane named here is what is now called Tim Lane.

71. Lord Bridge Aqueduct, 1923

Immediately upstream from Lord Bridge, in the valley between Haworth and Oakworth, not far from Spring Head (47), is a second bridge dated 'KCWW 1922', which carries a water pipeline. This takes treated water from Lower Laithe Reservoir and treatment plant to the Bracken Bank service reservoir. There is thus treated water crossing the River Worth in both directions at Lord Bridge. It took quite some time for me to realise that the pipe taking water to Haworth from Oldfield (see 70) was suspended under the road bridge and hidden from view. This fine coloured section and plan show the details of the aqueduct bridge of 1922, by which water goes from Lower Laithe to Keighley.

72. Keighley Corporation Waterworks, 1898
73. Keighley Corporation Waterworks, 1898, detail of Sladen Valley

The Bully Trees and Lower Laithe reservoirs, which were included in the Act of 1868, had still not been built thirty years later when this fine map was drawn in 1898. The map shows virtually the whole of the Sladen Valley from its sources on Stanbury Moor almost to its confluence with the River Worth at Long Bridge. It looks as though problems with the Bully Trees site might already have been encountered as a modified New Bully Trees Reservoir is shown here, though the difference from the original proposal is slight. Lower Laithe Reservoir is not mentioned at all.

The principal purpose of this map is to delineate the land that would need to be purchased under Act of Parliament to construct the works. The main map is very similar to a 6 inch OS map, while the details of individual farms are more like the 25 inch OS plans. Although we have the 1894 25 inch plans for most of this area, the large-scale details of Middle Withins, Top Withins and New Laithe ('Enlarged plan at No. 2') are very useful as the 25 inch survey does not extend so far west. These are best seen on map 73 (which has required some reorganisation of the enlarged details to fit them all in).

74. Lower Laithe Reservoir, 1912

Serious work on Lower Laithe Reservoir (the spelling varies – I have adopted that used by the Ordnance Survey) finally started around 1912. The original Bully Trees (supply) and Lower Laithe (compensation) reservoirs had been abandoned as the geology at the Bully Trees dam site was unsuitable. The New Lower Laithe Reservoir shown in this plan served both purposes: supply and compensation. Construction was delayed by the war but it was finally opened by the Marquis of Hartington (later the 10th Duke of Devonshire) in 1925.

At the head of the reservoir is a separate pool with its own small dam. This is, as the label states, a residuum lodge where silt was allowed to settle out before the water passed into the reservoir proper. With periodic dredging this helped to protect the reservoir from excessive sedimentation, which would reduce its capacity.

Three buildings were lost when the reservoir was built: Little Mill (unlabelled – between K1 and J1), Smith Bank and Lower Laithe itself.

Smith Bank was a small settlement; the lower parts of the site lie below the water while the main farm buildings were on the line of the flood water channel. The old road from Oxenhope to Stanbury, Waterhead Lane, was also submerged when the reservoir was filled. It was replaced by the present road, which runs on top of the reservoir's embankment. Dale Moor (always pronounced Dollymoor) near the filter beds has also been lost since the reservoir was built.

75. Keighley Corporation Waterworks with Bradford Corporation Waterworks reservoirs, etc., 1898

In the first half of the nineteenth century, the population of Bradford grew from 13,000 to over 100,000 as it became a major centre of the wool trade. Its need for fresh supplies of water was particularly acute. By the end of the 1850s, it was taking water from the Manywells Spring near Denholme and from Barden Moor and Grimwith in the Yorkshire Dales.

This Keighley Waterworks map of 1898 shows the works that Bradford Corporation Waterworks constructed in the 1870s in the Worth Valley. There are the two long conduits feeding Thornton Moor and Stubden (here mistakenly named Shibden) reservoirs and the compensation reservoirs at Leeming and Leeshaw. Bradford's reservoirs near Denholme are seen at the eastern edge of the map and two of Halifax's reservoirs (Warley Moor and Ogden) to the south. The coloured areas represent the gathering grounds for Keighley's reservoirs.

76. Bradford Corporation Waterworks, Leeming Reservoir, 1868

This parliamentary plan for Leeming Reservoir is perhaps the best record we have of two small mills that were lost when the reservoir was built. Throstle Nest Mill presumably took its water from Nan Scar Beck. The channel from the mill dam to the internal wheel pit is clearly shown. The name of this mill is presumably a humorous reference to the throstles that were employed

in spinning. They were a kind of water frame and took their name from the noise they made, which was likened to the song of the throstle or song thrush. The source of Midge Hole Mill's name will be obvious to anyone who has walked beside a Pennine beck on a summer's evening. The manuscript addition in red is a water supply to another of Leeming's mills – Sykes Mill, which can still be seen, although it is now converted to housing.

77. Bradford Corporation Waterworks conduits, 1868

The most striking features of Bradford's Worth Valley waterworks are the two 4-mile-long aqueducts, which take water to the Thornton Moor and Stubden reservoirs. To compensate the Worth Valley mill owners for the water diverted by these conduits, two reservoirs were made. These were the Leeming and Leeshaw compensation reservoirs. Each of them had a mile-long conduit of its own. This 1868 map shows the compensation reservoirs with their conduits and the Stubden conduit more or less as they were constructed. However, the Thornton Moor scheme had not yet been planned and the map shows an earlier idea. There were to be two reservoirs at Stairs and Shady Bank, each with its own catchwater drain to supply it with water. The water held in these reservoirs would have been fed into Stubden Reservoir via pipes running down to the Stubden conduit. Note the long tunnel, which carries the Stubden conduit out of the Worth Valley on its final approach to Stubden Reservoir.

66. Watersheddles Reservoir, 1868. (x0.45; 12" = 1 mile)

67. Ponden–Watersheddles Aqueduct, 1868. (x0.6; 4" = 1 mile)

68. Ponden Reservoir, 1868. (x0.4; 10" = 1 mile)

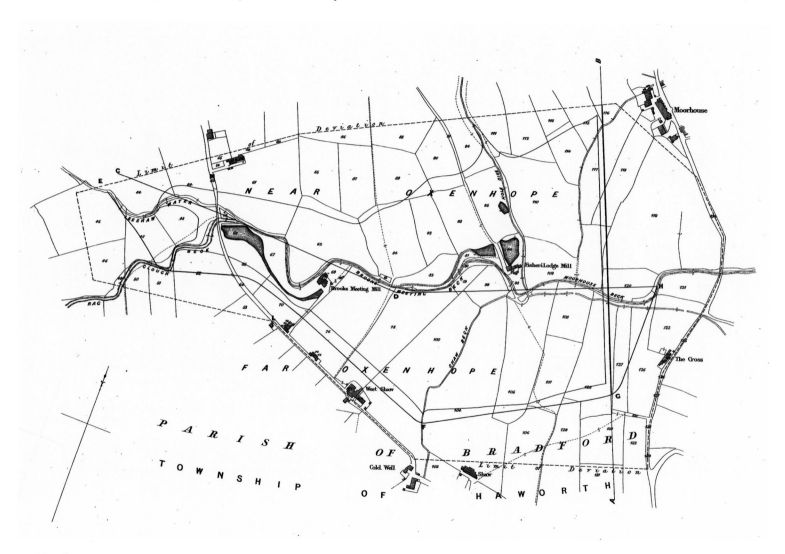

69. Moorhouse Reservoir (proposed), 1868. (x0.4; 10" = 1 mile)

70. Oakworth–Haworth Aqueduct, 1868. (x0.8; 5" = 1 mile)

71. Lord Bridge Aqueduct, 1923. (x0.7; 1" = 12 feet)

72. Keighley Corporation Waterworks, 1898. (x0.3; 2" = 1 mile)

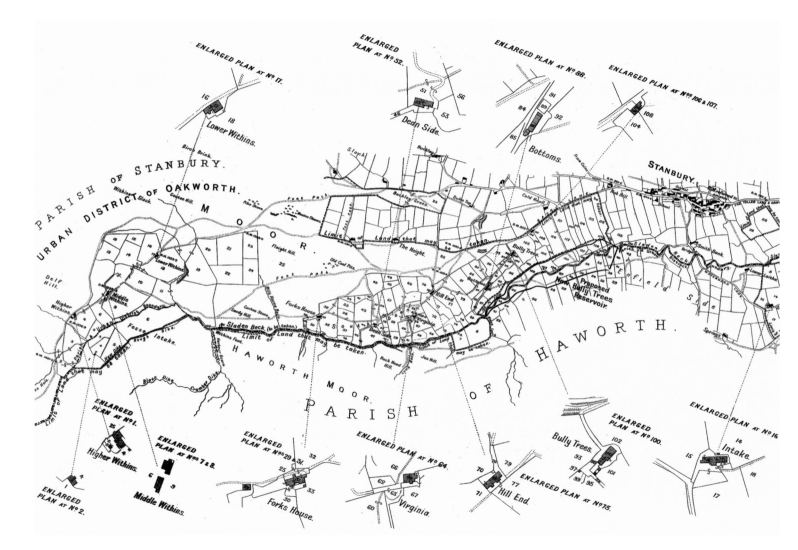

73. Keighley Corporation Waterworks, 1898, detail of Sladen Valley. (x0.6; 4" = 1 mile)

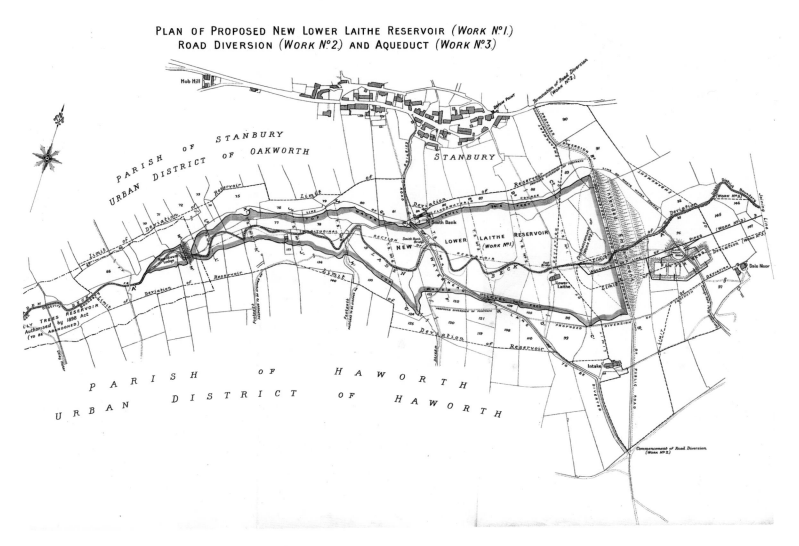

PLAN OF PROPOSED NEW LOWER LAITHE RESERVOIR (WORK Nº I.)
ROAD DIVERSION (WORK Nº 2) AND AQUEDUCT (WORK Nº 3.)

74. Lower Laithe Reservoir, 1912. (x0.3; 8" = 1 mile)

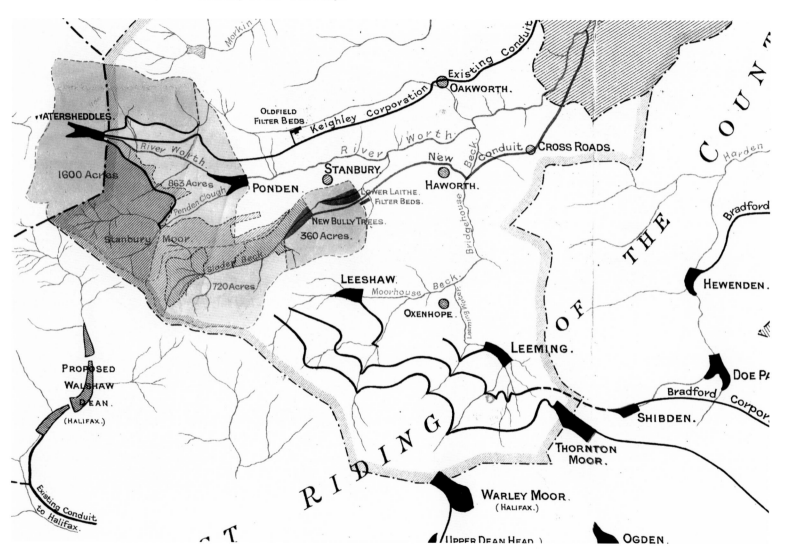

75. Keighley Corporation Waterworks with Bradford Corporation Waterworks reservoirs, etc., 1898. (XI; 1" = 1 mile)

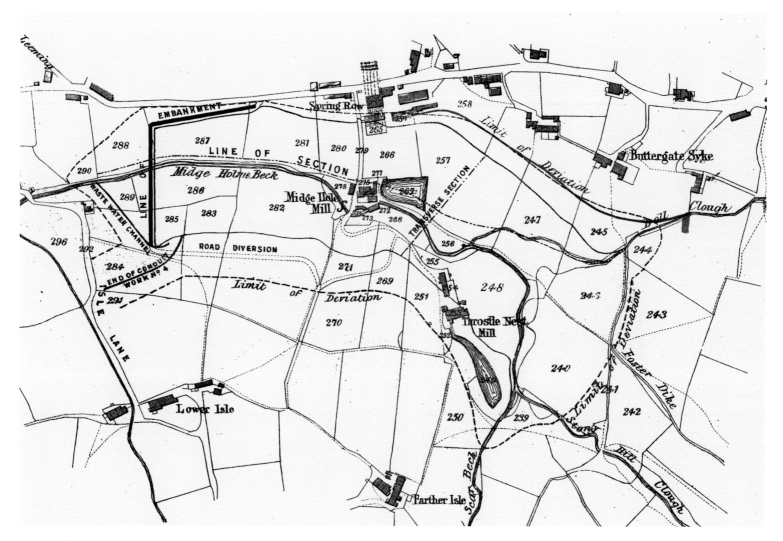

76. Bradford Corporation Waterworks, Leeming Reservoir, 1868. (XI; 16" = 1 mile)

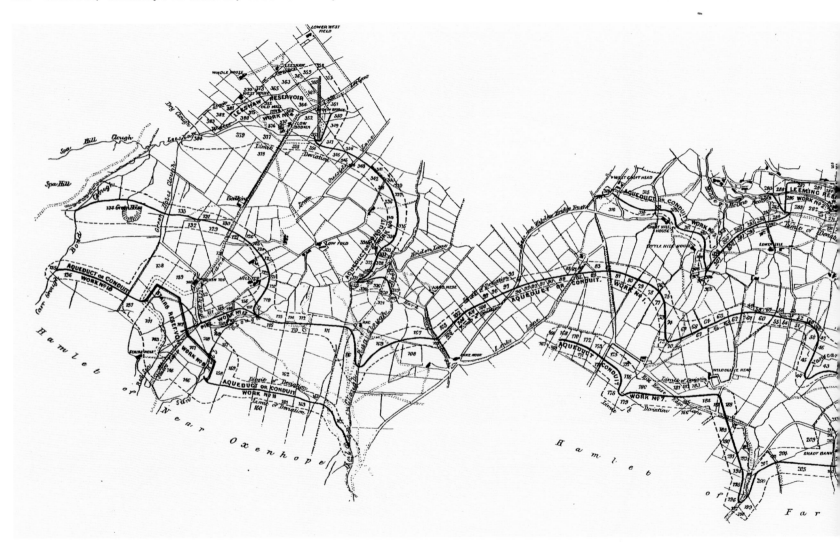

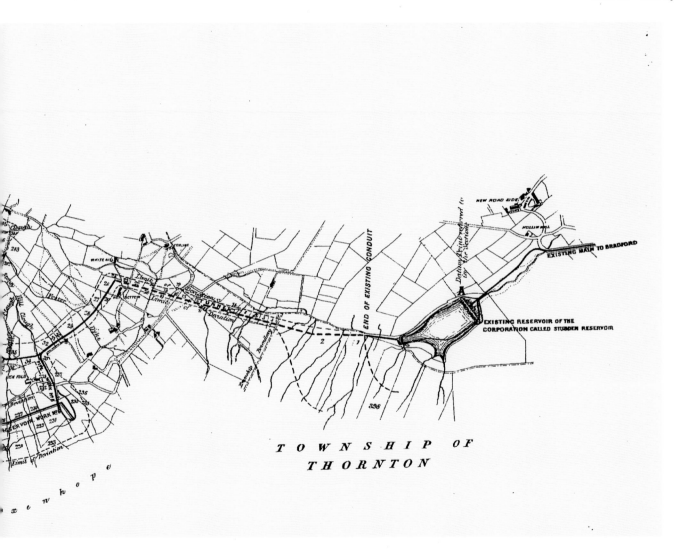

77. Bradford Corporation
Waterworks conduits,
1868. (x0.6; 4" = 1 mile)

RAILWAY & ROAD PLANS

Railways, like reservoirs, produce an extensive archive of maps and other documents of great use to the local historian. There were a number of proposals for railway lines to Haworth and beyond in the nineteenth century, including a branch from the Leeds to Skipton line (78) and a railway from Bradford to Colne (79). Eventually, a group of local mill owners successfully undertook the building of a branch line from Keighley, which opened in 1867. It was operated by the Midland Railway and eventually taken over by them. The line closed in 1962 but quickly reopened and it is now run as a very successful preserved steam railway.

78. Leeds & Bradford Extension, the Worth Valley branch, 1845

The earliest proposed railway to Haworth for which we have a map is this branch off the Leeds & Bradford Extension at Keighley. Close to Vale Mill the line splits in two. The northern branch follows the River Worth and is clearly designed to serve Mytholmes Mill and Spring Head Mill. The southern branch is quite close to the route of the branch that was eventually built. It runs close to the Bridgehouse Beck, passing near Ebor Mill, crossing the road at Mill Hey and terminating at Bridge House Mill. It is obvious that this line was designed principally for the five mills close to its route. It seems likely that this proposal was designed to placate the Worth Valley mill owners and that there was never any serious intention of building it.

79. East Lancashire Railway's (ELR) Bradford–Colne line, Haworth to Ponden section, 1856

In contrast to the 1845 proposal (78), this colourful map depicts a line that was obviously designed principally to connect Bradford and Colne. Haworth and its mills seem to have been incidental to its main purpose.

Again, there was probably no real intention of building this line, its real purpose being to influence the Lancashire & Yorkshire Railway's (L&Y) negotiations with the ELR. Its route shown here is just north of the road from Haworth to Stanbury. Hollings, Griff and Ponden Mills are near the line. The large scale details are useful as they come almost forty years before the first 25 inch OS plan. They depict (right to left) Cook Gate Manor, the Sladen Bridge cottages and Milking Hill farm, Griff Mill and the New Inn, Hob Lane (now the Old Silent).

80. Keighley & Worth Valley Railway (KWVR) parliamentary plan, c. 1862

We now come to maps and plans of the Keighley & Worth Valley Railway that was actually built. This extract from the parliamentary plan starts (on the right) where the line enters Haworth township near Lower Mytholmes farm. It continues past Ebor Mill, Haworth corn mill and Bridge House Mill then follows the Bridgehouse Beck towards the terminus at Oxenhope. Haworth station is not marked but was built just by the corn mill on Mill Hey.

81. Haworth Station final survey, Bridgehouse area, c. 1867

I have added street names etc. to this plan for clarity. The goods yard and Station Road were built on an area that had been levelled by tipping. The bottom end of Bridgehouse Lane and the bridge over the railway and the beck were also new. These replaced the old line of the turnpike road, which is shown running immediately in front of Bridge House Mill and the Belle Isle cottages. The original course of the stream is indicated with the position of the old road bridge over it. The new drive to Woodlands runs alongside the repositioned Ivy Bank Lane. Note the Belle Isle Inn at the top of the plan.

82. Oakworth Deviation, Vale Viaduct, 1890

The original railway line of 1867 crossed the Vale Mill dam by a wooden trestle bridge. In 1892, this was replaced when the line was reconstructed through Mytholmes tunnel. This plan of the new deviation shows Vale Viaduct and the proposed new line. The inset painting of Vale Mill gives us an excellent picture of the old viaduct. The locomotive is just crossing the mill dam.

83. Haworth Goods Yard, 1885 and 1919

After the Midland Railway bought the line in 1886 they made a number of improvements. One was the reorganisation of Haworth goods yard. The upper plan of 1885 shows that the switches (or points) were then at the Up line (Keighley) end of the yard. By 1919 the switches were at the other end of the goods yard. The main reason for doing this was to ensure that any runaway stock would be heading uphill towards Oxenhope rather than downhill towards Oakworth (in 1875 a runaway train at Oakworth got all the way to Keighley). The new goods shed, the enlarged station building and the new footbridge over the line from Belle Isle Road are also shown.

84. Haworth Station proposed zigzag railway with details, c. 1910

When Keighley Corporation built Lower Laithe reservoir at Stanbury it needed to get heavy machinery and materials to the reservoir site. It made sense to use the railway to get things as close as possible before using road transport. This plan shows part of a proposed standard gauge line to the reservoir site from Haworth station. This zigzag railway would have lifted the reservoir branch up to the fields above the station before it headed for Stanbury. The project must have proved too expensive as it was never built. Oxenhope station was used as the railhead for the reservoir works.

85. KWVR detailed plan – Haworth Station, 1916
86. KWVR detailed plan – Oxenhope Station, 1916

In 1915 and 1916 a quite remarkable map of the KWVR was produced. The whole line is displayed in great detail at a scale of 40 inches to the mile. The survey from Keighley to Ebor was done by T. O. Marshall in 1915 and that from Ebor to Oxenhope by Geo. Mills in 1916. These two half-scale extracts are taken from the latter and show the stations and goods yards at Haworth and Oxenhope. Every detail of the railway is shown: station buildings and platforms, goods sheds, cranes, platelayers' huts, offices, gas meters and fire hoses. They also show much useful detail of buildings close to the railway. Notable at Haworth (85) is the corn mill with all the details of its water supply. The unusual arrangement of goits supplying Oxenhope Mill is very well shown on the Oxenhope map, as is the tail goit (86, see also 50). Oxenhope Mill provides a good example of the practice of extending mill buildings across the stream to make full use of a restricted site. The filter beds in the top left corner are those of the Oxenhope sewage works. The plan extends well beyond Oxenhope station as the railway had built Station Road to serve the mills at Lowertown.

87. Lees & Hebden Bridge Road, Lees to Haworth/Wadsworth boundary, 1813

Roads generally leave far less in the way of records than railways but turnpike trusts did keep minute books, which often survive. There are two turnpike roads through Haworth; the 1760 Blue Bell road from Bradford to Colne has left no map. The 1813 Lees and Hebden Bridge road over Cock Hill was a completely new road and did need mapping. This map is a redrawing of the road from its beginning to the Haworth boundary on Cock Hill. The letters refer to a table of the landowners over whose property the road was to be built.

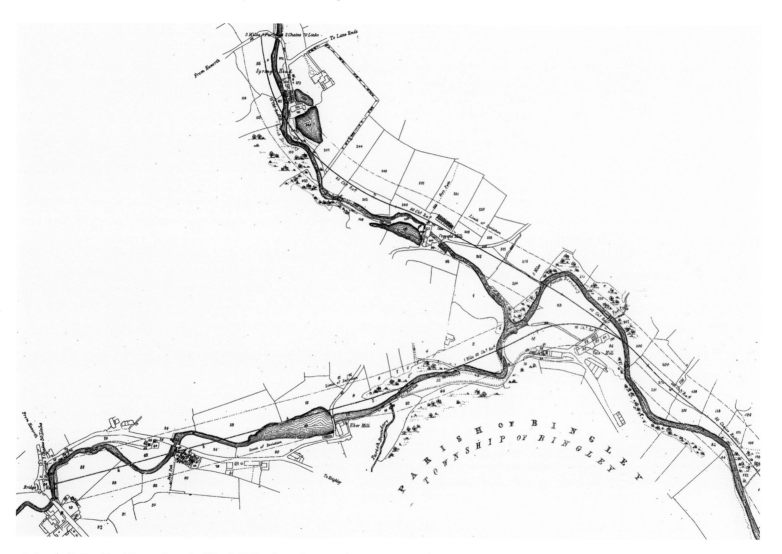

78. Leeds & Bradford Extension, the Worth Valley branch, 1845. (x0.5; 8" = 1 mile)

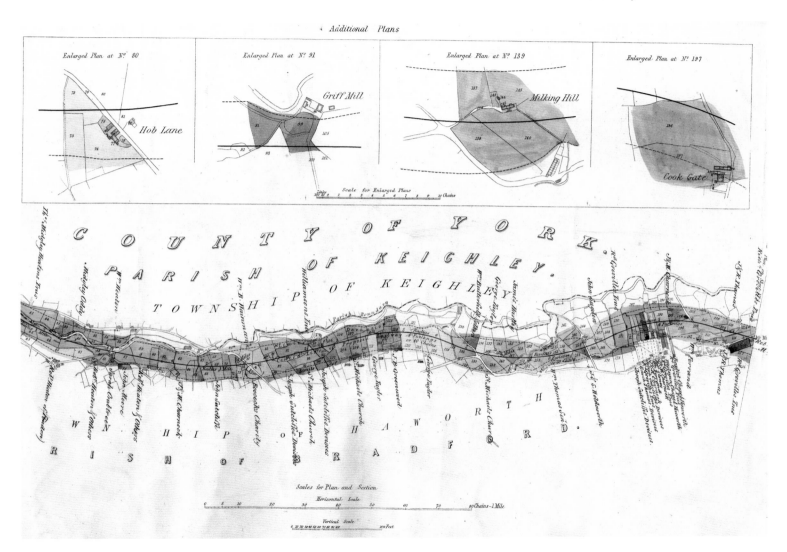

79. Bradford–Colne line, Haworth to Ponden section, 1856. (x0.5; 3" = 1 mile. Details 10" = 1 mile)

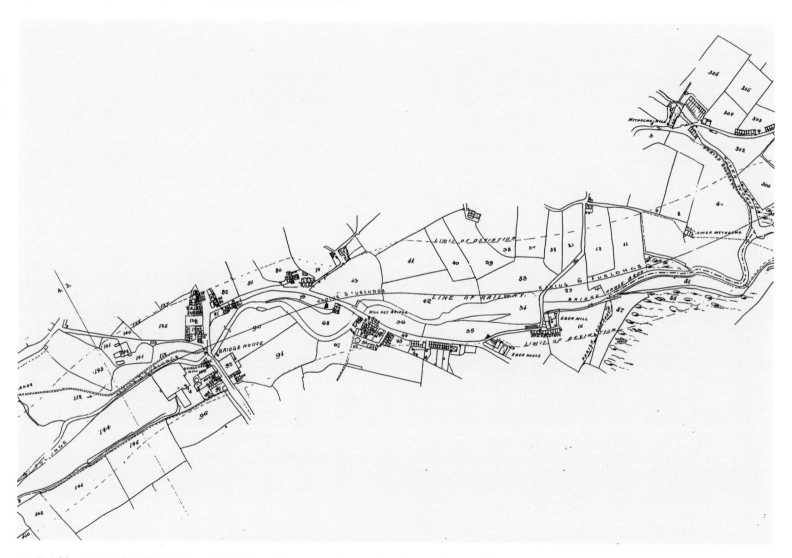

80. Keighley & Worth Valley Railway (KWVR) parliamentary plan, *c.* 1862. (x0.6; 9" = 1 mile)

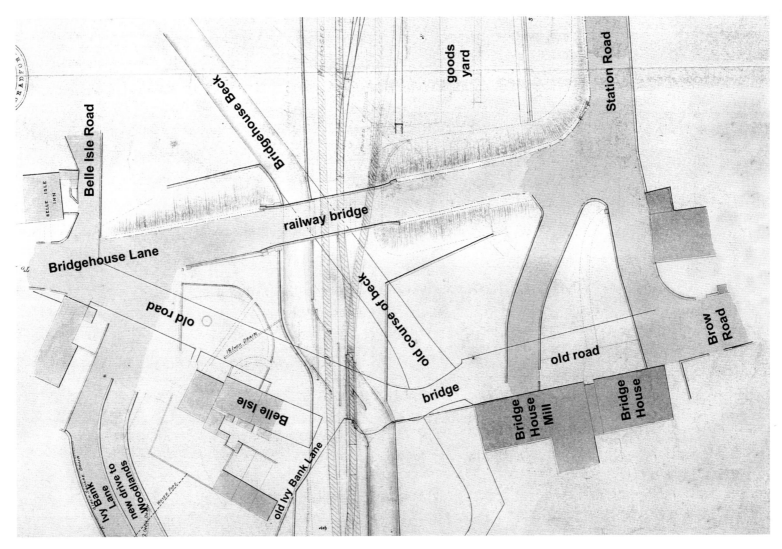

81. Haworth Station final survey, Bridgehouse area, c. 1867. (x0.6; 80" = 1 mile)

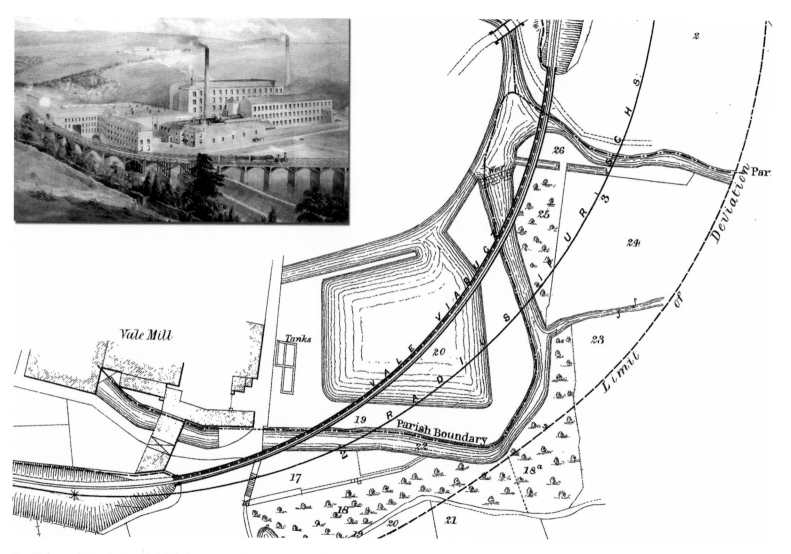

82. Oakworth Deviation, Vale Viaduct, 1890. (XI; 32" = I mile)

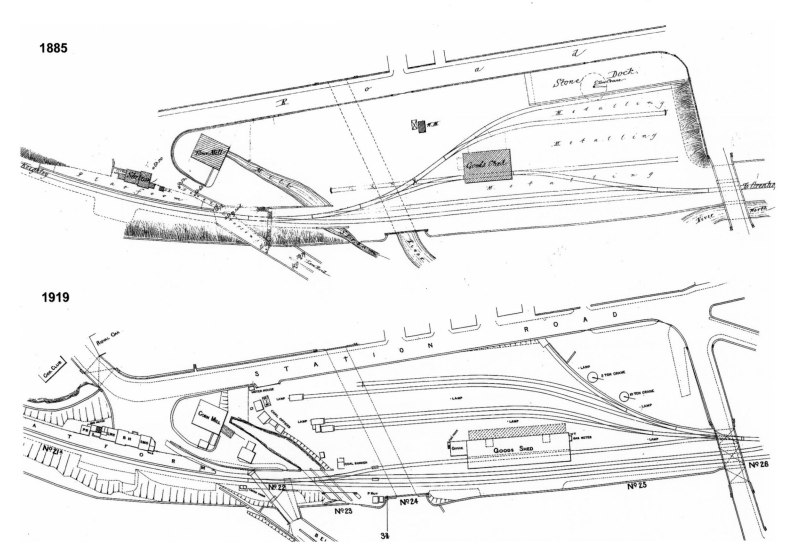

83. Haworth Goods Yard, 1885 and 1919. (xo.33; 44" = 1 mile)

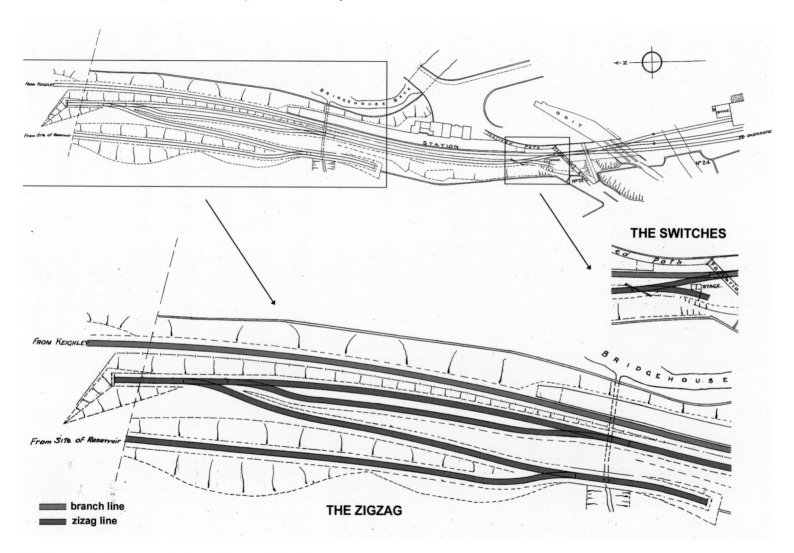

84. Haworth Station proposed zigzag railway with details, *c.* 1910. (x0.25; 34" = 1 mile. Details x0.5; 68" = 1 mile)

85. KWVR detailed plan – Haworth Station, 1916. (x0.5; 20" = 1 mile)

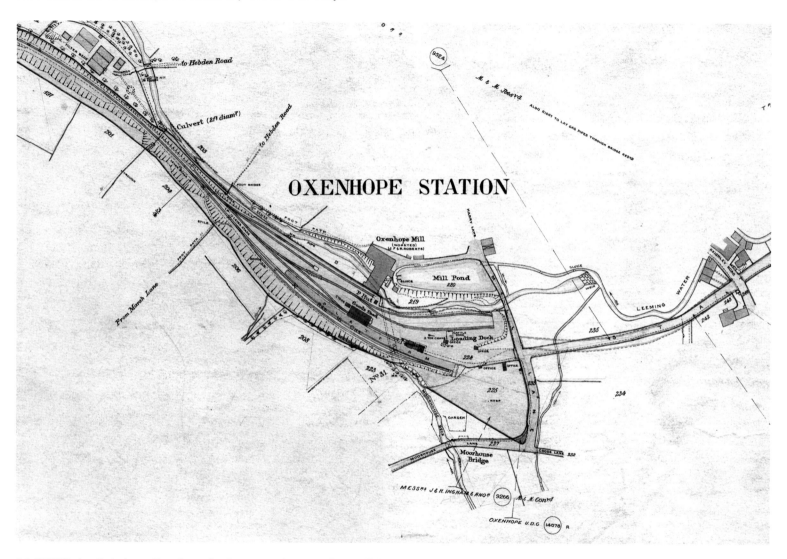

OXENHOPE STATION

86. KWVR detailed plan – Oxenhope Station, 1916. (x0.5; 20" = 1 mile)

87. Lees
& Hebden
Bridge Road,
Lees to
Haworth/
Wadsworth
boundary,
1813. (x0.7;
4" = 1 mile)

THE LEES & HEBDEN BRIDGE TURNPIKE ROAD TO THE
HAWORTH-WADSWORTH BOUNDARY.

Adapted from a tracing of the original map of 1813 at Wakefield Archives.

Scale = approx 5 inches to 1 mile

S.C. Wood, September 1988

BUILDING PLANS

Keighley Library holds a very large collection of building plans for the Haworth area dating from *c.* 1880 to 1938. A few of the most interesting ones are included here.

88. Victoria Road, four houses, plans, 1878
89. Victoria Road, four houses, elevation, 1878
The earliest Haworth plan is this one of Nos 16 and 18 Mill Hey (they were originally four back-to-back houses). The two sheets display most features to be seen on building plans: a block plan giving the location, plans, sections and elevations of the buildings and outbuildings. In the early plans the elevations are often beautifully drawn and hand-coloured. These houses, which were near the Gas Street car park entrance, were demolished in the 1970s.

90. Victoria Road, houses and stable, 1879
Another early plan depicts three properties in Victoria Road. Unfortunately, there is no block plan but they are probably the present Nos 2, 4 and 6 Victoria Road. What is most unusual about this proposal is that the end house is actually a stable. If it was ever built like this it has since been converted to an ordinary dwelling.

91. Carlton Street, house, section and plans, 1888
The most detailed of all the house sections is this generalised section of eight houses in Carlton Street and Clarence (now Dean) Street. The one depicted must be one of the Carlton Street houses: 27, 29, 31 and 33. I have placed reduced copies of the three floor plans next to each storey shown on the section. On the ground floor the kitchen is on the left, with its slop stone under the window and a set pot for hot water. In the other room is the fireplace with a small range. In a recess to the right of the fire is the cupboard with drawers underneath, very typical of houses of this period.

92. Top Street, elevation, 1887
This elevation accompanies a crude plan for a new coal place in Top Street. It provides us with a good picture of a part of Haworth that was probably never photographed at that time. The archway is the well-known one that goes through to the top of Main Street from Piccadilly. The odd structure beneath the window to the left of the archway is the proposed coal bunker. The buildings shown are the backs of Nos 80 and 82 Main Street.

93. Acton Street, plan, 1901, with portrait of Jack Kay
Acton Street, where this new privy and ash place were to be built, was once the home of one of Haworth's most interesting characters. The square house just below the red privy building was No. 6 Acton Street, where Old Jack Kay lived until his death in 1847. He had a great reputation as a wise man who told fortunes and thwarted the ill intentions of the local witches. The lower inset shows this house (on the right with the gas lamp); the other inset is a portrait of Jack Kay still owned by his family.

94. Belle Isle shop, plan and elevation, 1921
After the Belle Isle Inn (81) closed, a grocer's and off-licence was set up in part of the premises in 1901. It belonged to the brewer Samuel Ogden, who made this application to extend the premises in 1921 when the shop was run by John William Halstead. It was to continue in business under various proprietors for another fifty years. The plan gives a good idea of the kind of small shop that was common in Haworth until the 1960s.

95. Co-op Store, Main Street, elevation, 1937
The first Co-op shop in Haworth opened at the bottom of Main Street in 1861. In 1866, it moved to a shop a little further up the street where, in 1897, the building shown here was put up. This elevation shows the new shop-front, which was added in 1937. It gives us a better picture of the appearance of the main Co-op store than any surviving photograph.

96. New Inn, Stubbing Lane, plans and section, 1901
The New Inn on Stubbing Lane (now Sun Street) first appears in the trade directories in 1822 and it closed in 1930. At the time of this plan the landlord was Jesse Carter. This plan, submitted in connection with new drains, gives a very full picture of the layout of this long closed public house. The tap room and bar were close to the entrance, with the bar parlour and another unlabelled public room – probably the snug – nearby. A club room upstairs would have been used for private parties and, perhaps, for friendly society meetings. With four bedrooms the New Inn might have had one spare for overnight accommodation. As well as a kitchen for food preparation there are a scullery for dishwashing and a wash kitchen for laundry etc. There is stabling for five horses.

97. Belle Isle Hippodrome Cinema, plans, elevations and section, 1913
The older of Haworth's two cinemas, the Hippodrome on Belle Isle Road, was locally known as 't'owd uns'. These plans, elevations and sections give us a very good idea of what it must have looked like when it first opened in 1913.

98. Temporary Theatre, plan and elevations, 1910
Travelling theatres were a feature at fairs in the Victorian and Edwardian eras. The wooden theatre shown in this blueprint was erected on the fairground (now the park) in 1910. We are very fortunate to have a wonderful description of this, or a very similar theatre, in Lizzie Rignall's autobiography – I can do no better than to quote it in full:

At about the same period too a wooden hut would be erected, in which a troupe of travelling players gave nightly shows of rich melodrama, or comedies based on 'Chips' or 'Comic Cuts'. Weary Willie and Tired Tim were the leading characters in one such production. The arrangements were quite primitive. For twopence you sat at the back on wooden forms raised in tiers with nothing but a plank to walk on and gaping space below should you place a foot unwarily. Fourpence earned you a seat on terra firma – chairs these were, not forms; and the plutocrats sat in a few rows of small armchairs in front which cost sixpence.

We of course could afford no more than twopence so we sat in 'The Gods'. The production which above all others I enjoyed the most – 'A Royal Divorce' – was a melodrama of Napoleon and Josephine which had a great vogue at that time. But my own enjoyment of it came from a most unusual reason. I went to see it with my bosom friend Emily, and for a while everything was quite circumspect and we were absorbed in the plot. Suddenly however something struck Emily as being either funny or ridiculous and she began to giggle. The giggle became a positive guffaw, and Emily's guffaw was something to be remembered. So whole hearted was it that she finally fell helplessly through the boards and down to ground level under the stand in utter darkness. From there came shrieks of merriment, rising higher and higher and in which I perforce had to join.

The show came to a halt of course and an irate official arrived to eject the offenders. To find and oust me was simple; but this was in the days before electric torches became ubiquitous; and to find Emily, down in the depths, moving about all the time in profound darkness and still hooting with laughter was not quite such an easy matter. However she was found at last, escorted firmly to the door and thrown out. But we had had a good twopennyworth!

88. Victoria Road,
four houses, plans,
1878. (X0.3)

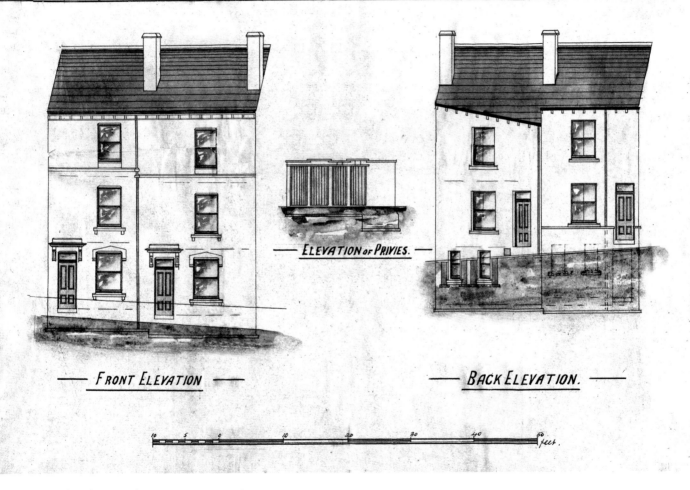

— PROPOSED FOUR HOUSES ADJOINING VICTORIA ROAD AND HIGHWAY, HAWORTH, FOR Mr JOHN CRABTREE. —

ELEVATION OF PRIVIES.

FRONT ELEVATION

BACK ELEVATION.

89. Victoria Road, four houses, elevation, 1878. (x0.5)

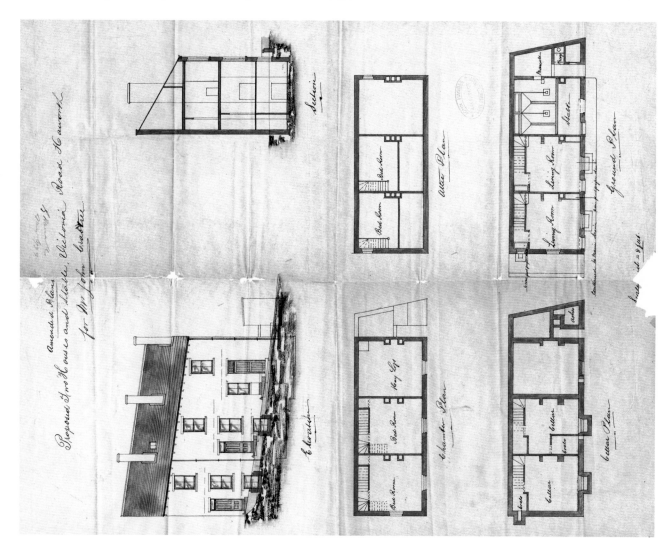

90. Victoria Road, houses and stable, plans and elevation, 1879. (x0.5)

FLOOR PLANS
(half section scale)

BED ROOM

GROUND FLOOR

CELLAR

91. Carlton Street, house, section and plans, 1888. (x0.3 and x0.15)

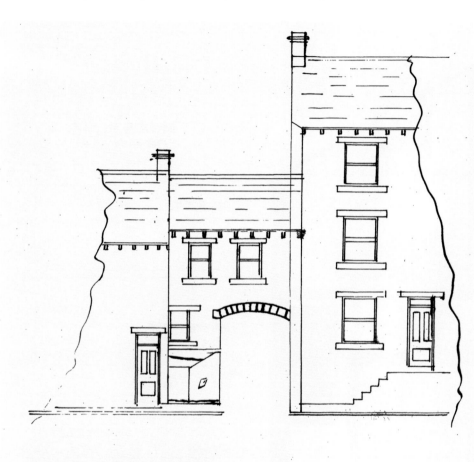

SCALE OF FEET

92. Top Street, elevation, 1887. (x0.75)

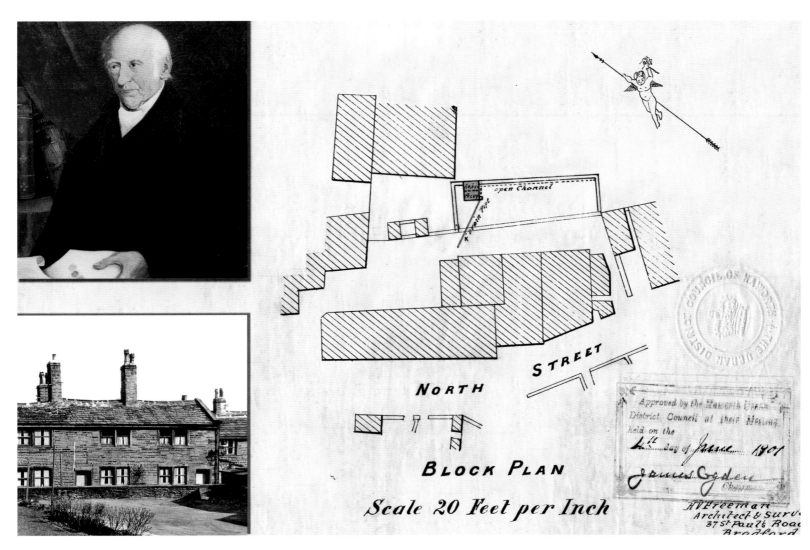

open Channel

NORTH STREET

BLOCK PLAN

Scale 20 Feet per Inch

Approved by the Haworth Urban
District Council at their Meeting
held on the 4th day of June 1901

James Ogden
Chairman

H V Freeman
Architect & Surv
37 St Pauls Road
Bradford

93. Acton Street, plan, 1901 (x0.6) with portrait of Jack Kay.

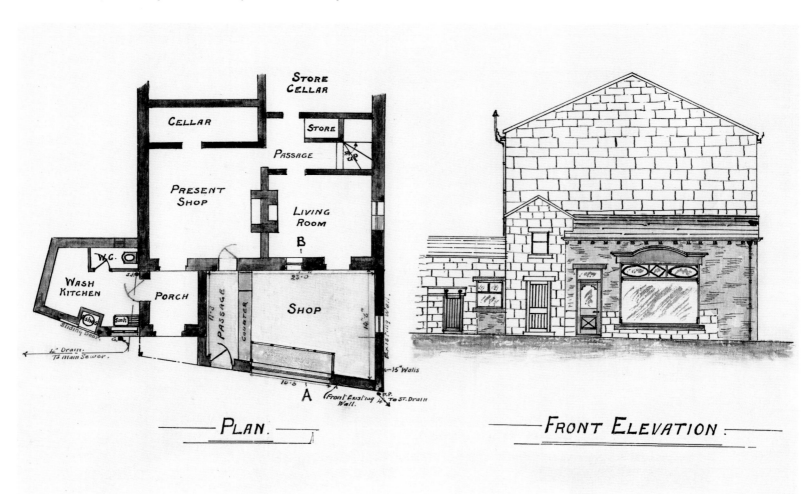

94. Belle Isle, shop, plan and elevation, 1921. (x0.66)

95. Co-op Store, Main Street, elevation, 1937. (x0.6)

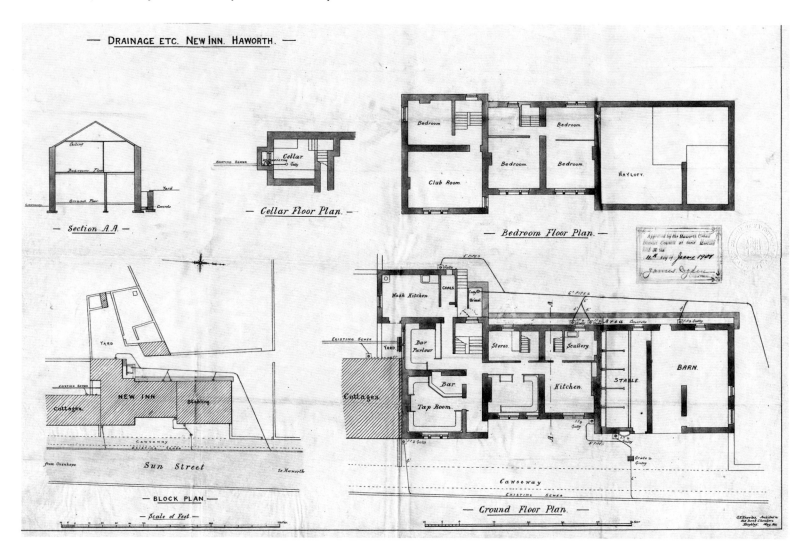

— DRAINAGE ETC. NEW INN. HAWORTH. —

— Section A.A. —

— Cellar Floor Plan. —

— Bedroom Floor Plan. —

— BLOCK PLAN —

— Scale of Feet —

— Ground Floor Plan. —

96. New Inn, Stubbing Lane, plans and section, 1901. (x0.3)

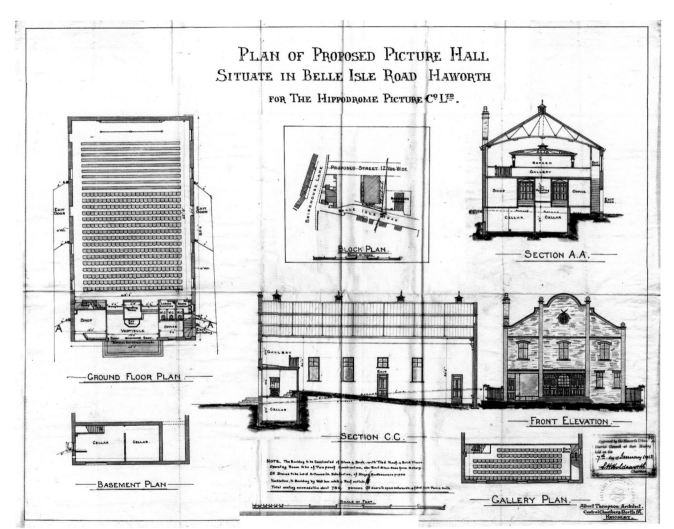

97. Belle Isle Hippodrome Cinema, plans, elevations and section, 1913. (x0.25)

98. Temporary Theatre, plan and elevations, 1910. (x0.4)